Thoreau's New England

Thoreau's New England

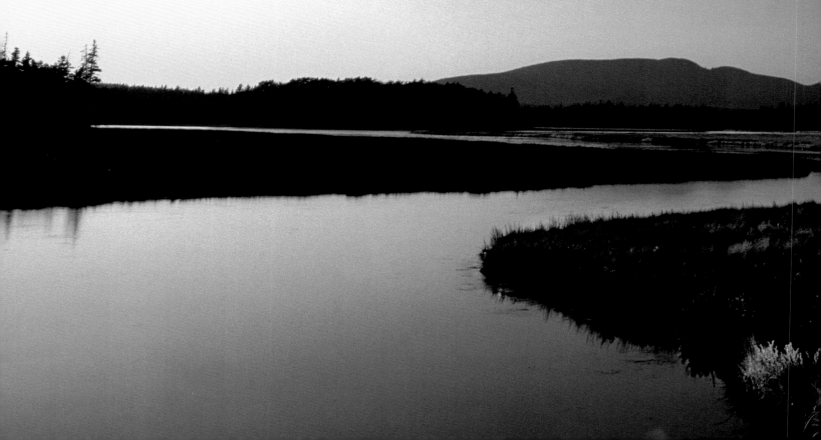

Photographs and Selections

By Stephen Gorman

UNIVERSITY PRESS OF NEW ENGLAND

HANOVER AND LONDON

Published by University Press of New England,
One Court Street, Lebanon, NH 03766
www.upne.com
© 2007 by Stephen Gorman
Printed in China
5 4 3 2 1

Library of Congress Cataloging-in-Publication Data
Gorman, Stephen.
Thoreau's New England / photographs and selections by Stephen Gorman.
p. cm.
ISBN-13: 978–1–58465–581–7 (cloth : alk. paper)
ISBN-10: 1–58465–581–X (cloth : alk. paper)
1. New England—Pictorial works. 2. New England—History, Local—Pictorial works. 3. Landscape—New England—Pictorial works. 4. Thoreau, Henry David, 1817–1862—Quotations. 5. Thoreau, Henry David, 1817–1862—Homes and haunts—New England. I. Title.
F5.G66 2007
974'.0440222—dc22 2006033931

Contents

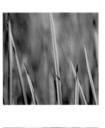

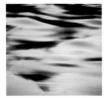

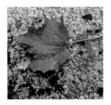

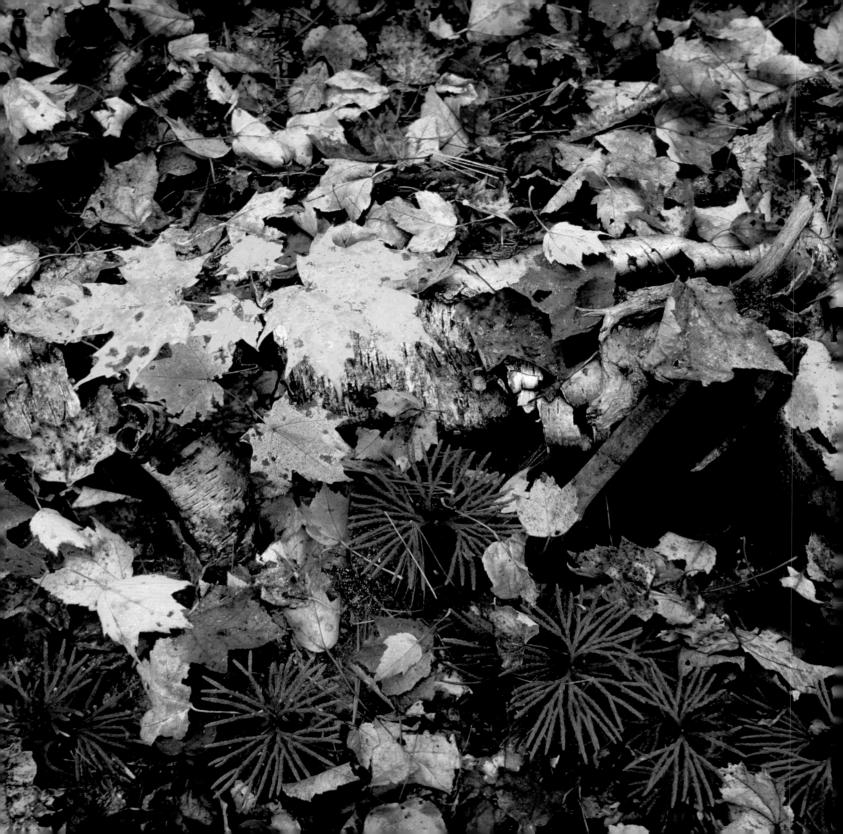

Acknowledgments

My heartfelt gratitude goes to all those New Englanders who have spoken up for and fought to preserve Thoreau Country—the cherished landscape and way of life that make this region unique. If you are looking for a way to contribute to this cause, becoming involved in one or more of the 350-plus land trusts in New England is an excellent way to help preserve our region's best qualities. I thank the citizens and organizations that carry on the never-ending struggle to preserve the heritage and beauty of this special place against formidable, well-financed, and often deceptive opponents. Without your ongoing efforts, the images in this book would not exist.

In fact, I hope the photographs in this book do not end up as a pictorial record of what our region once was but now is lost forever. Instead, I hope the images continue to reflect the beauty and majesty of our unique region for many generations to come.

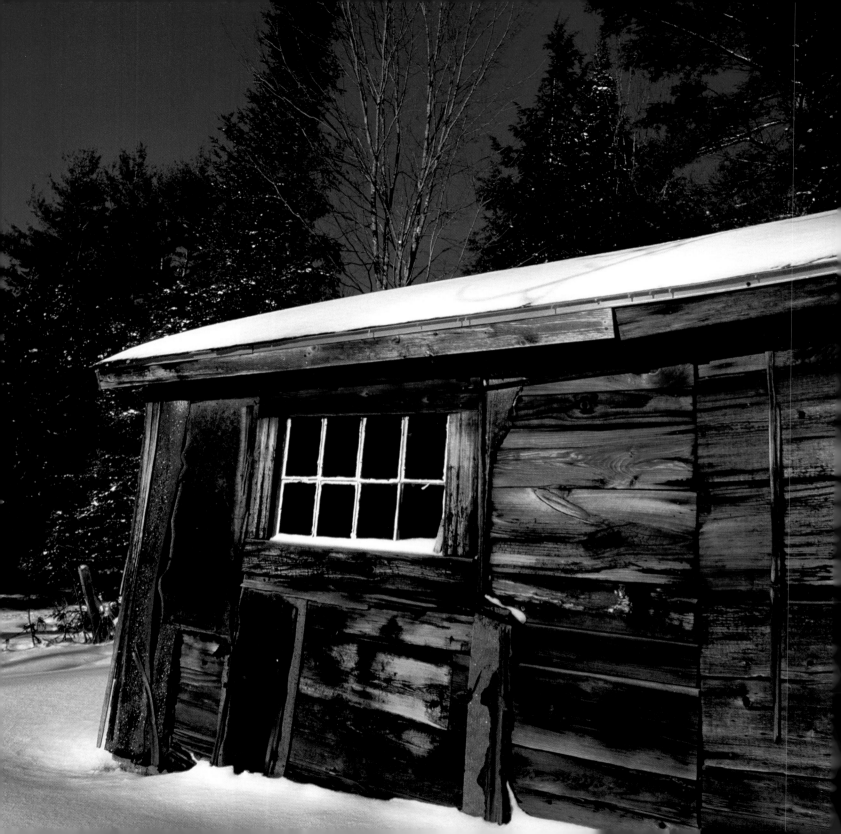

Prologue

I went to the woods because I wished to live deliberately, to front only the essential facts of life, and see if I could not learn what it had to teach, and not, when I came to die, discover that I had not lived. I did not wish to live what was not life, living is so dear; nor did I wish to practise resignation, unless it was quite necessary. I wanted to live deep and suck out all the marrow of life, to live so sturdily and Spartan-like as to put to rout all that was not life, to cut a broad swath and shave close, to drive life into a corner, and reduce it to its lowest terms, and, if it proved to be mean, why then to get the whole and genuine meanness of it, and publish its meanness to the world; or if it were sublime, to know it by experience, and be able to give a true account of it in my next excursion.

—Henry David Thoreau

Thoreau's New England

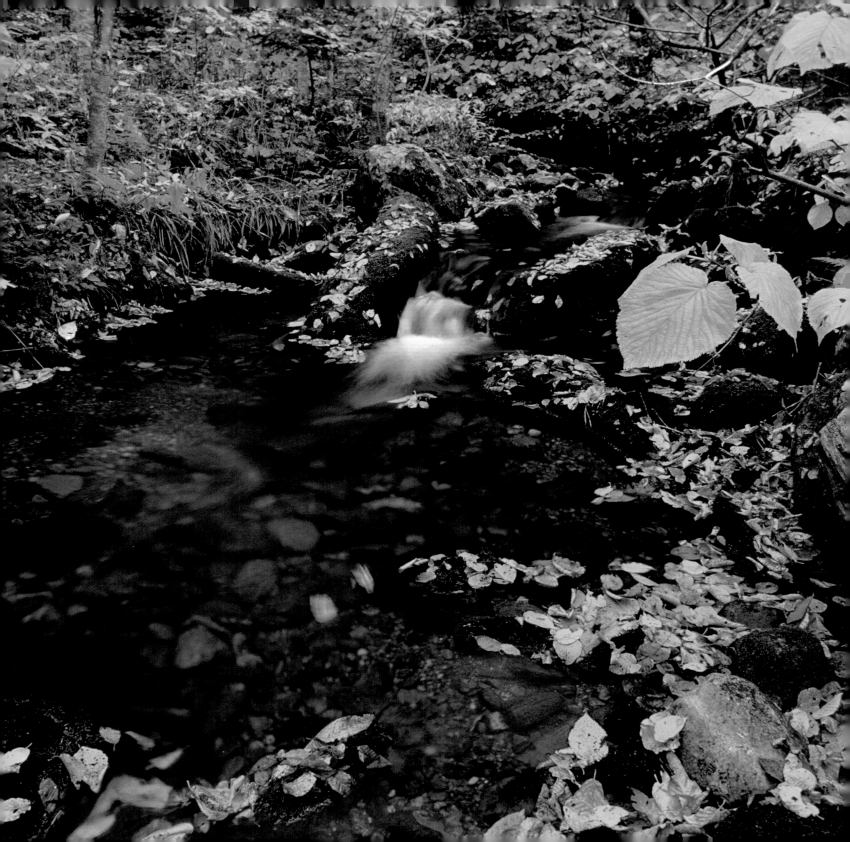

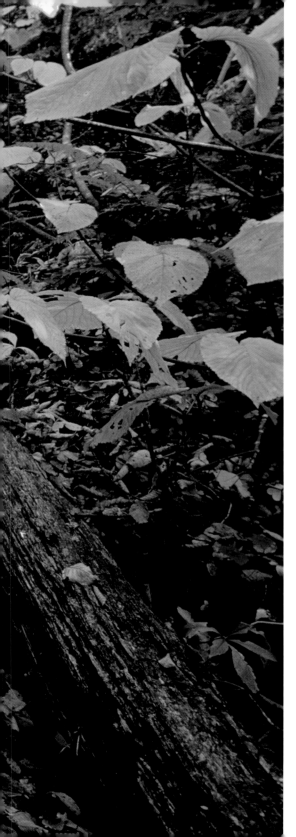

INTRODUCTION

Thoreau Country

All my life I have traveled west and returned home east. For years I tried to follow the exhortation attributed to Horace Greeley, "Go West, young man, and grow up with the country." But it didn't take. Bucking both our national myth of westward manifest destiny and actual demographic trends, I made the reverse migration from Colorado back to New England. And even though I was (and still am) awed and inspired by the extravagant western landscape, at a crucial moment I returned home to New England and caught a glimpse of Thoreau Country, and I have never recovered from that encounter.

The spirit of Henry David Thoreau lives on in a thousand places throughout New England. From the arctic tundra of the high mountain summits, through the heavily forested uplands, down the raging wilderness rivers, to the sandy shores of Cape Cod, it is still possible to experience the same power of untamed nature that so impressed Thoreau. Here nature is truly in charge, and no matter where you go, even in the towns and cities, you are never very far from the outdoors. This is still an uncompromising landscape—often harsh and demanding, sometimes benevolent, but rarely gentle. Whether

you're navigating a wintry nor'easter in downtown Boston or battling polar conditions in the Presidential Range, here nature touches your life directly much as she did 150 years ago.

In Thoreau Country life goes on to a great extent as it used to. Far from shopping malls and suburbs, here lives an America that is being eradicated just about everywhere else. Many who live, work, and play in Thoreau Country still feel a close personal connection to the land born of familiarity and respect. Perhaps in New England more than any other region, nature has molded the region's character, dictating who the people are, what they do, and when they do it. This closeness to nature defines the very soul of New England.

Of course, not all of the region has escaped the ravages of our insatiable industrial culture. Boston, Hartford, and Providence are ensnared by superhighways and ringed by graceless suburbs. In some parts of the region residential development outpaces the valiant efforts of state and local conservation organizations.

Perhaps most alarming—a threat striking right at the heart of Thoreau Country—avaricious entrepreneurs and speculators hope to turn nature into profit by converting New England's wild mountaintops and seascapes into hideous industrial wind factories in order to provide us all with "green" power.

Faced with the threat of row upon row of 400-foot-tall otherworldly wind turbines covering New England's high country, I can imagine Thoreau quipping, "as if that was what the mountains were for, to become the footstools of wind turbines." I believe he might have added, "destroying the environment in order to save it is madness."

Reading Thoreau, I find him eerily prescient, as when he calls for the creation of a system of national preserves decades before the

dedication of our first national park; or when he describes the heavy costs of environmental destruction, arguing that humankind is not separate from, but is instead a part of, nature. His contention that what we do to the earth we do to ourselves has been proven again and again to our sorrow.

Though much of what Thoreau celebrated has been lost in the intervening century and a half, much remains. Whenever I leave the cities and the suburbs and head into the countryside, it isn't long before I notice a wild river rushing through a brilliant autumn wood, or see a sturdy white steepled church rising beneath a forested hillside, and I say to myself, "There it is, Thoreau Country!"

At those moments I know that in spite of the rampant development and the mindless destruction of large swaths of beautiful New England landscape, much of Thoreau Country remains intact, and there freedom and sanctuary and adventure may still be found. So far the rugged New England geography and climate has helped make sure of that, for much of the region is too cold, too harsh, and too remote to be truly endangered—yet.

Along with countless others I seek out those remaining parts of Thoreau Country, and their very existence comforts my soul. This book is my contribution to the future of this geography and landscape. I hope that the beauty of this place moves you, and I hope it moves you to action. Join your local land trust, get active in your town's conservation commission, and support local efforts at preservation. Thoreau's legacy will live on only if we embrace it and fight for the sacred places.

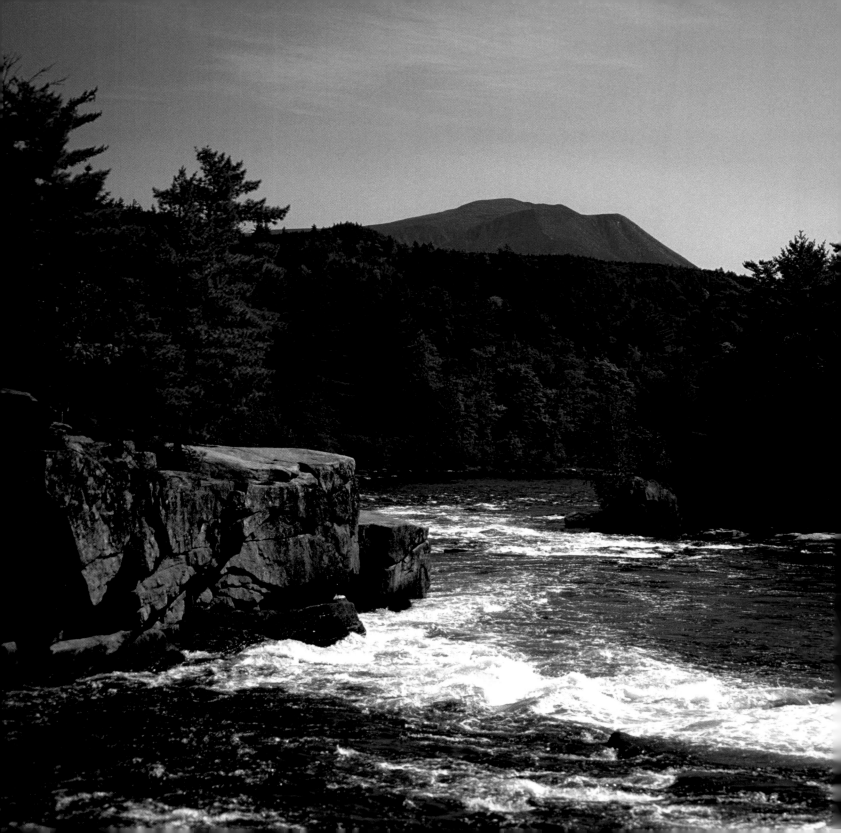

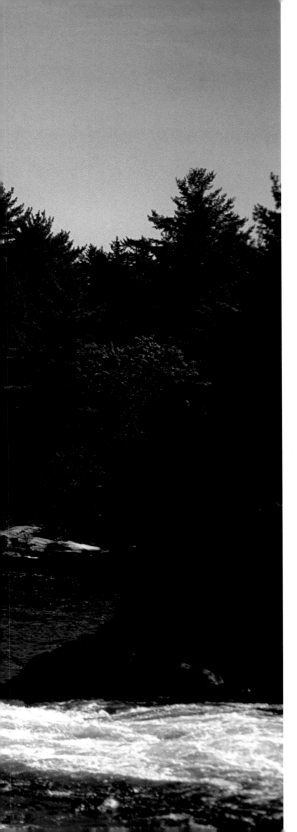

Wildness

In the New England wilds Henry David Thoreau discovered a natural realm of rivers, forests, mountains, lakes, dunes, beaches, and crashing waves, a place where one "might live and die and never hear of the United States, which make such a noise in the world, —never hear of America, so called from the name of a European gentleman."

Delighting in the freedoms he found "far from mankind and election day!" in the Maine woods, Thoreau relaxed by crackling campfires and listened with relish to the stories of his Indian guides. He paddled through raging whitewater, and he raced ahead of his companions up the summit ridge of Mount Katahdin as storm clouds swirled around him.

On Cape Cod Thoreau discovered a bewitching world where towering sand dunes and open ocean collide. On solitary treks along the Great Beach, he reflected upon the awesome power of the sea and its relationship to the shore, for it was here at the margin that the ocean revealed her secrets: "The sea, vast and wild as it is, bears thus the waste and wrecks of human art to its remotest shore. There is no telling what it may not vomit up. It lets nothing lie."

These and many other experiences in untamed nature shaped his belief that "in Wildness is the preservation of the world."

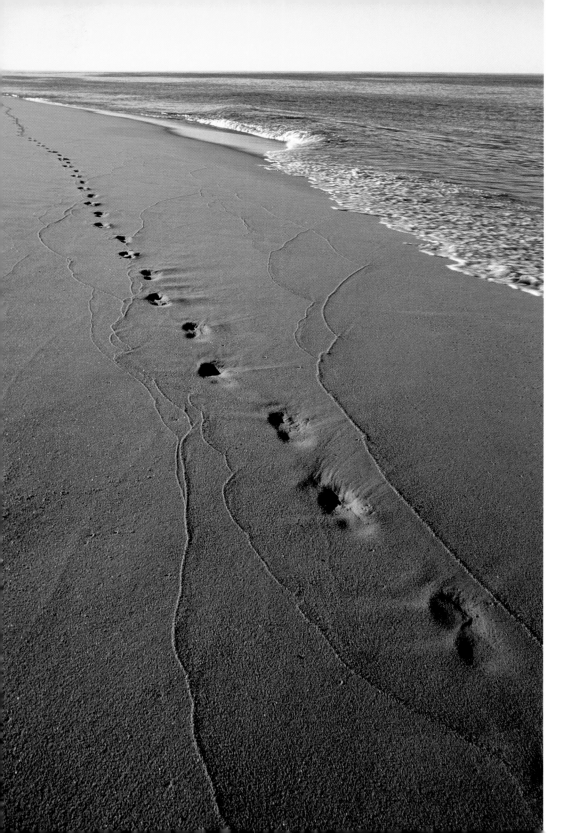

Heaven is under our feet as well as over our heads.

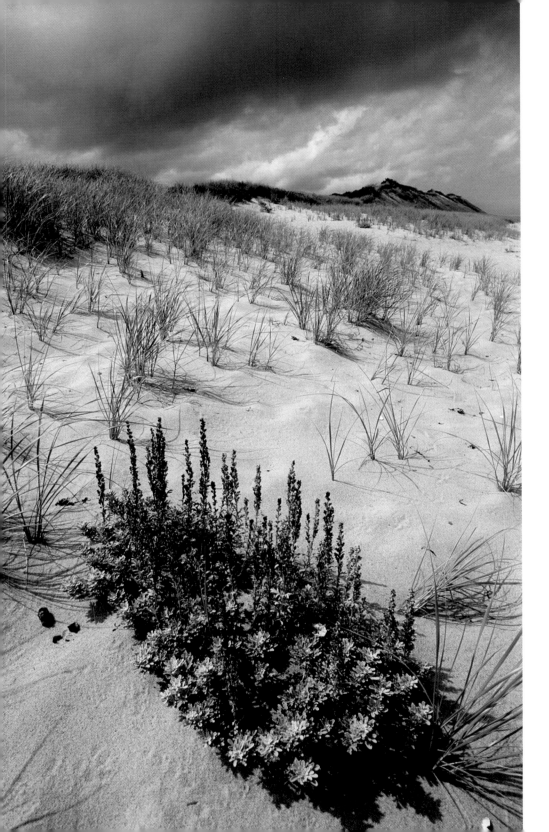

We can never have enough of nature. We must be refreshed by the sight of inexhaustible vigor, vast and titanic features, the sea-coast with its wrecks, the wilderness with its living and its decaying trees, the thunder-cloud, and the rain which lasts three weeks and produces freshets. We need to witness our own limits transgressed, and some life pasturing freely where we never wander.

7

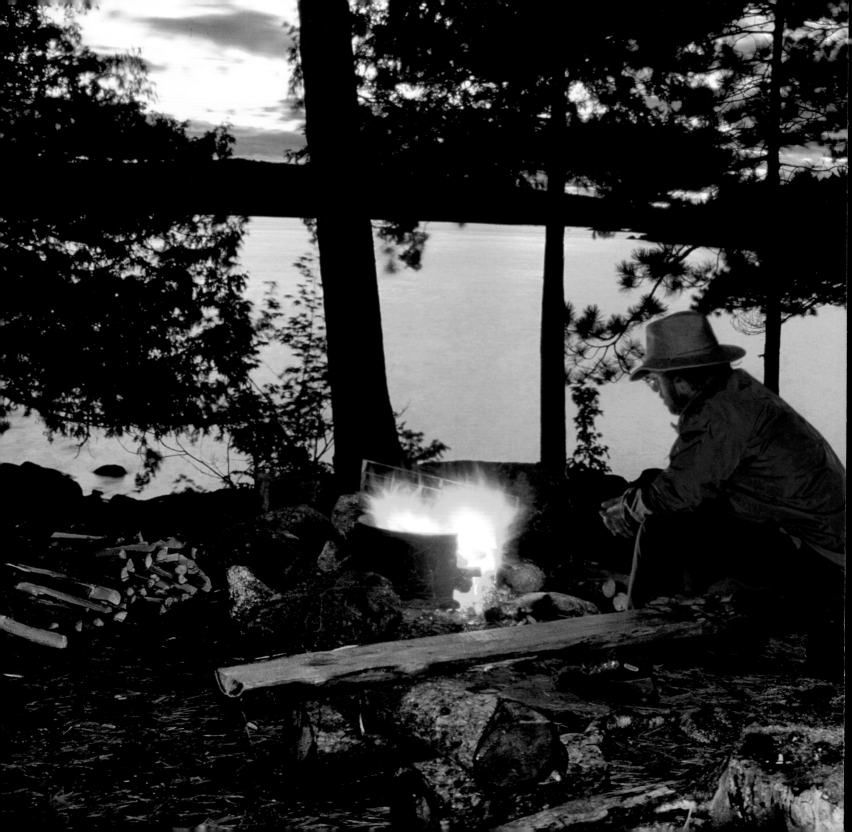

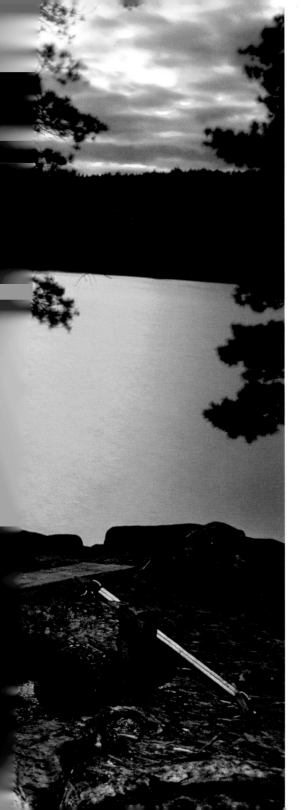

In the middle of the night, as indeed each time that we lay on the shore of a lake, we heard the voice of the loon, loud and distinct, from far over the lake. It is a very wild sound, quite in keeping with the place and the circumstances of the traveller, and very unlike the voice of a bird. I could lie awake for hours listening to it, it is so thrilling. When camping in such a wilderness as this, you are prepared to hear sounds from some of its inhabitants which will give voice to its wildness. Some idea of bears, wolves, or panthers runs in your head naturally . . .

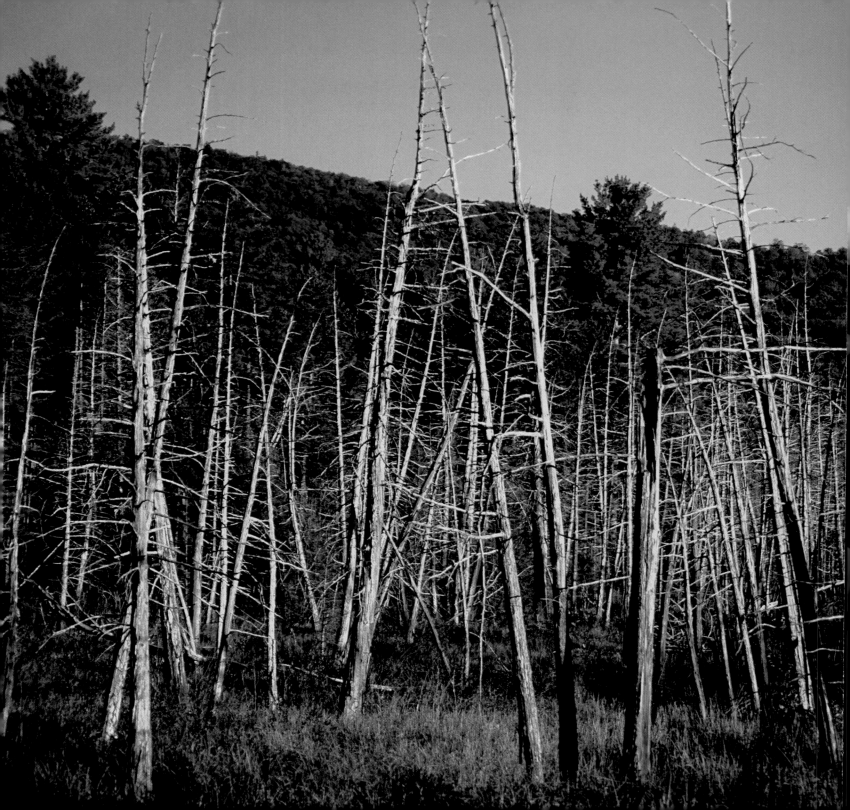

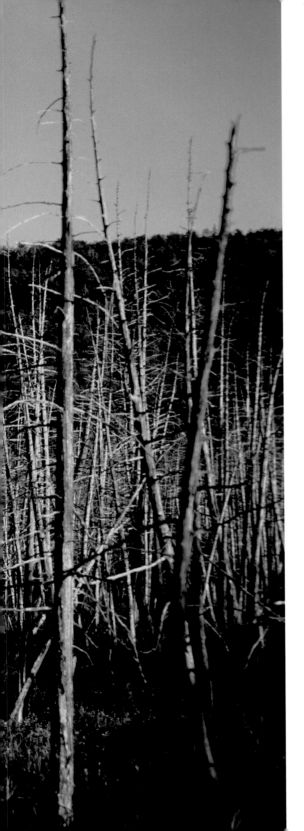

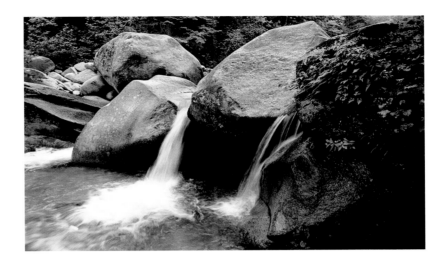

We are concerned now, however, about natural, not political limits.

For beauty, give me trees with the fur on.

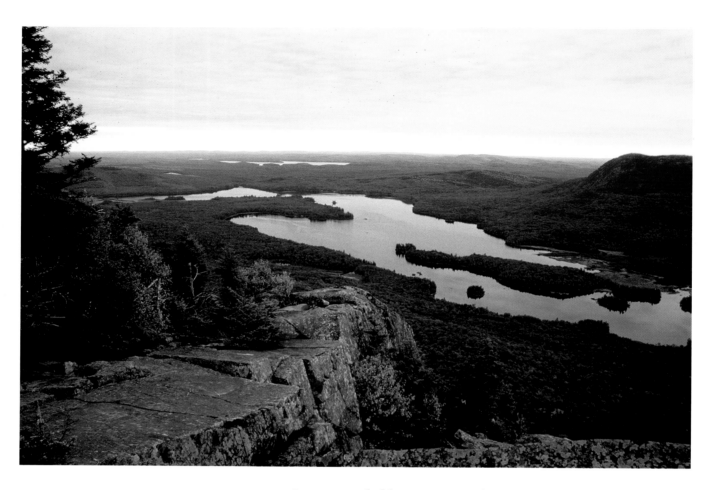

I am reminded by my journey how exceedingly new this country still is. You have only to travel for a few days into the interior and back parts even of many of the old States, to come to that very America which the Northmen, and Cabot, and Gosnold, and Smith, and Raleigh visited.

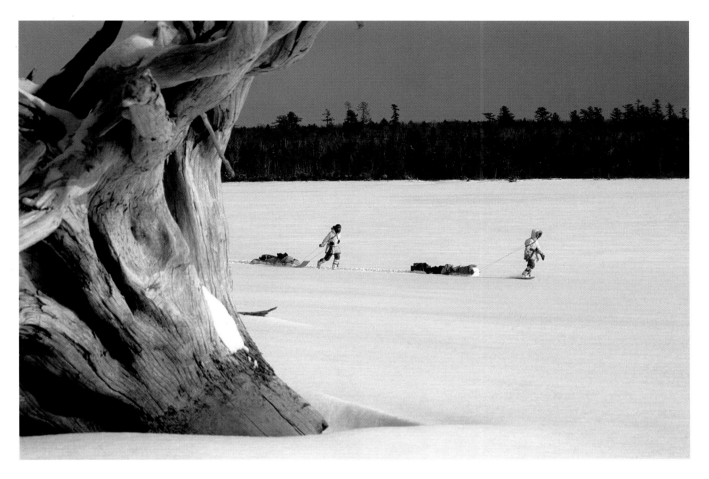

In the winter, however, which is very equable and long, the ice is the great highway, and the loggers' team penetrates to Chesuncook Lake, and still higher up, even two hundred miles above Bangor. Imagine the solitary sled-track running far up into the snowy and evergreen wilderness, hemmed in closely for a hundred miles by the forest, and again stretching straight across the broad surfaces of concealed lakes!

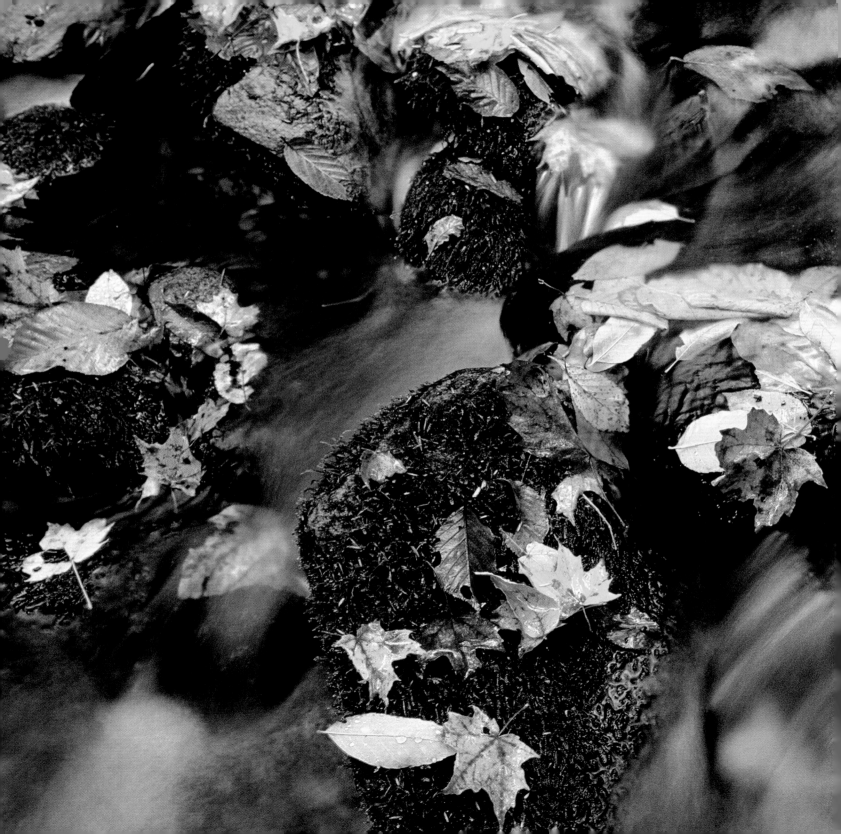

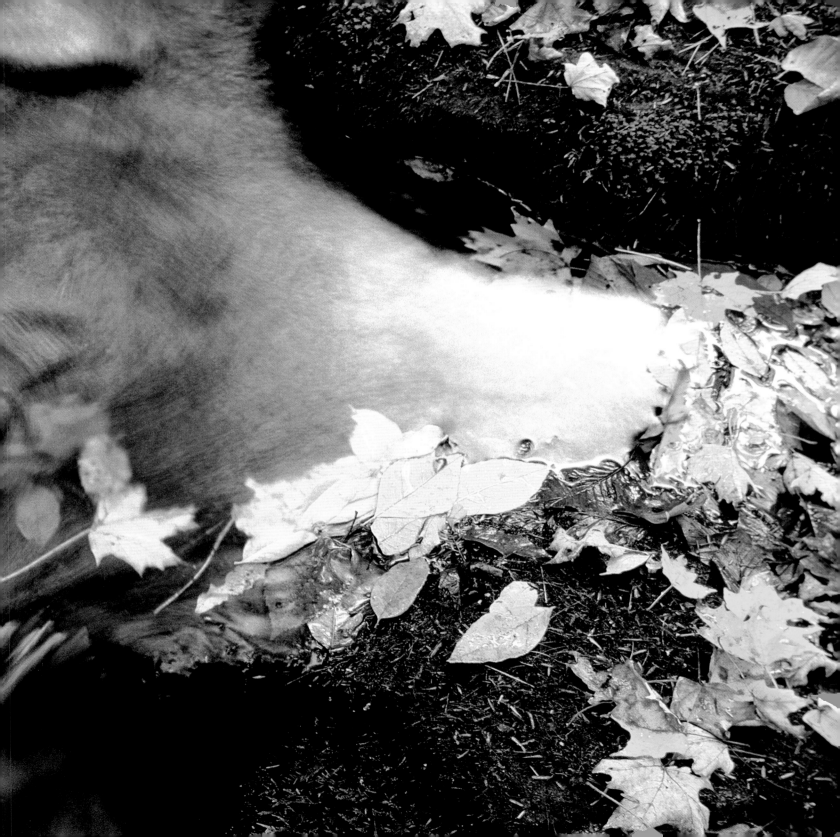

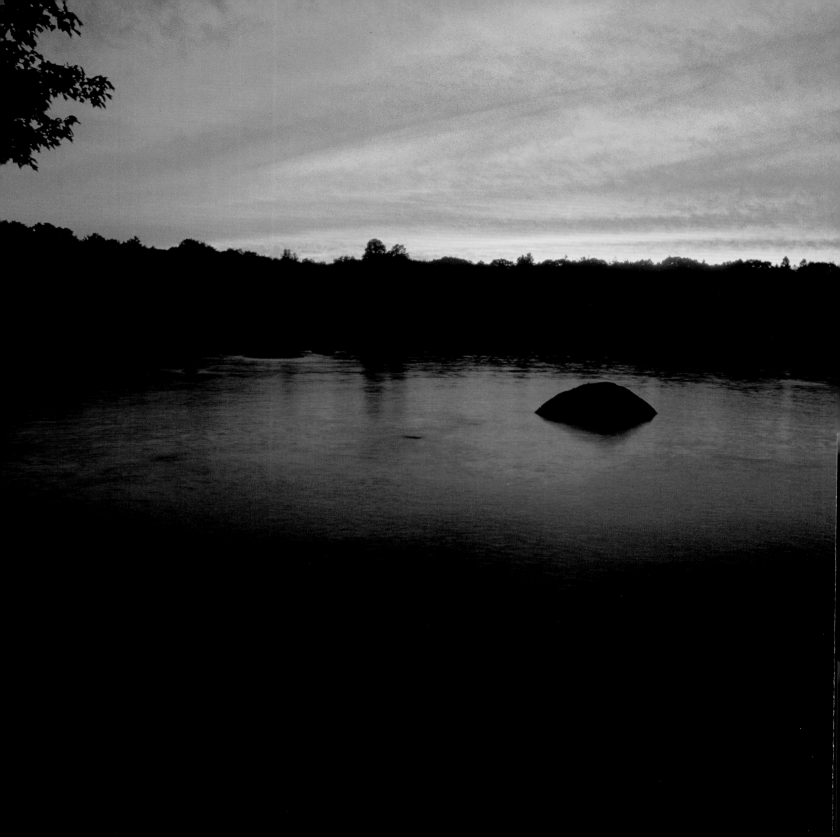

Give me a Wildness whose glance no civilization can endure . . .

Wherever there is a channel for water, there is a road for the canoe.

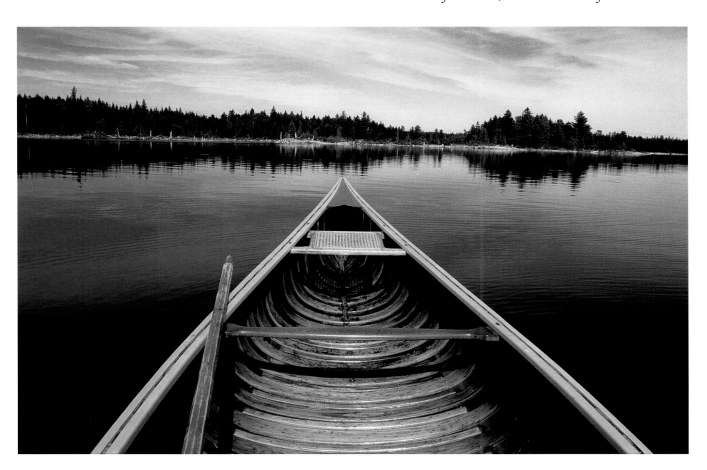

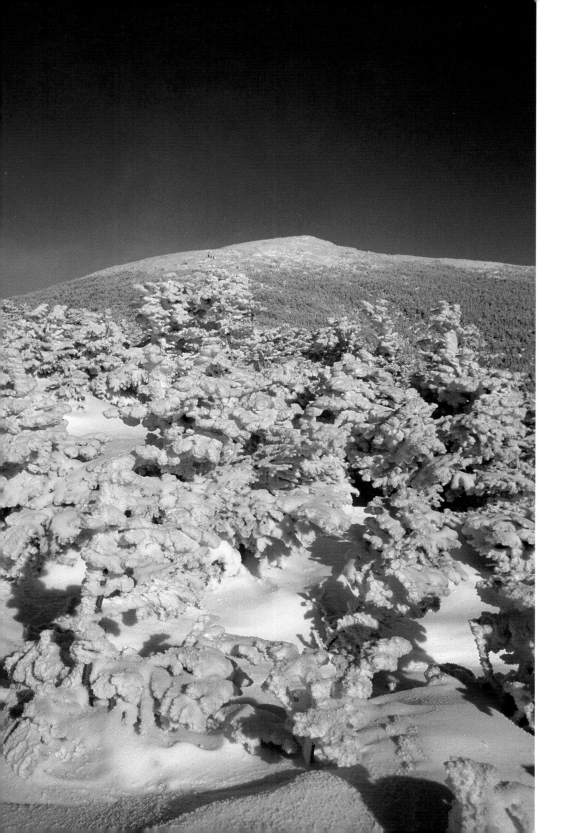

The tops of mountains are among the unfinished parts of the globe, whither it is a slight insult to the gods to climb and pry into their secrets, and try their effect on our humanity. Only daring and insolent men, perchance, go there.

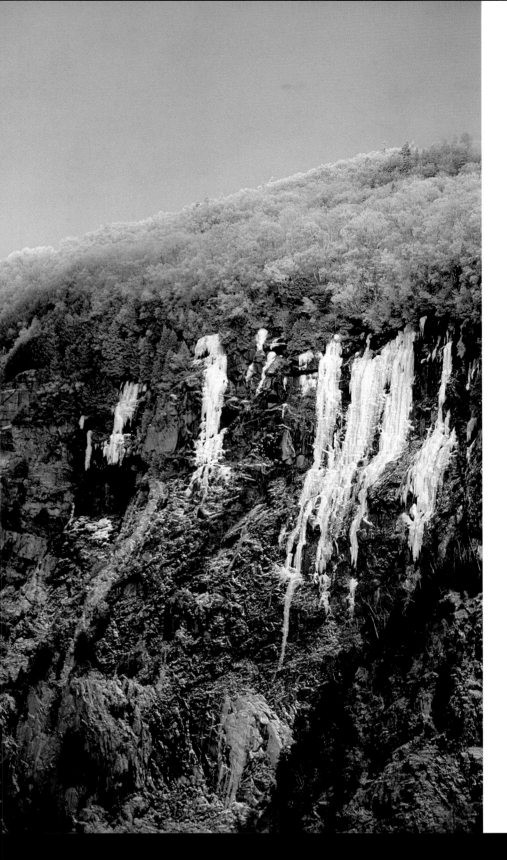

Vast, Titanic, inhuman Nature has got him at disadvantage, caught him alone, and pilfers him of some of his divine faculty. She does not smile on him as in the plains. She seems to say sternly, why came ye here before your time? This ground is not prepared for you. Is it not enough that I smile in the valleys? I have never made this soil for thy feet, this air for thy breathing, these rocks for thy neighbors. I cannot pity nor fondle thee here, but forever relentlessly drive thee hence to where I am kind. Why seek me where I have not called thee, and then complain because you find me but a stepmother? Shouldst thou freeze or starve, or shudder thy life away, here is no shrine, nor altar, nor any access to my ear.

19

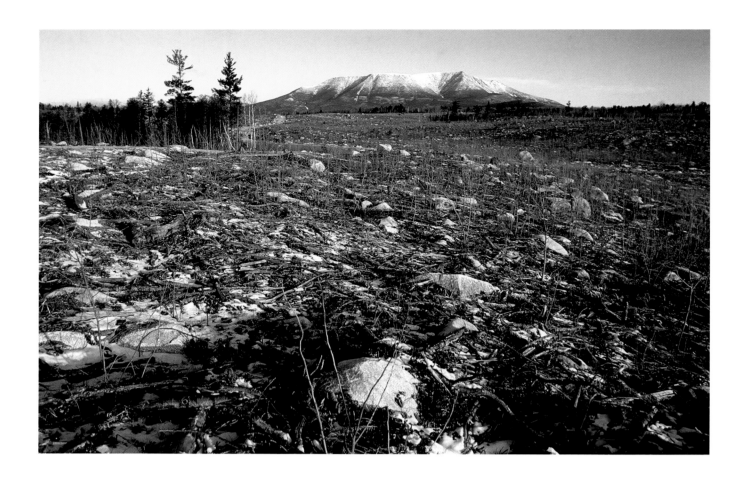

I would have liked to come across a large community of pines,

which had never been invaded by the lumbering army.

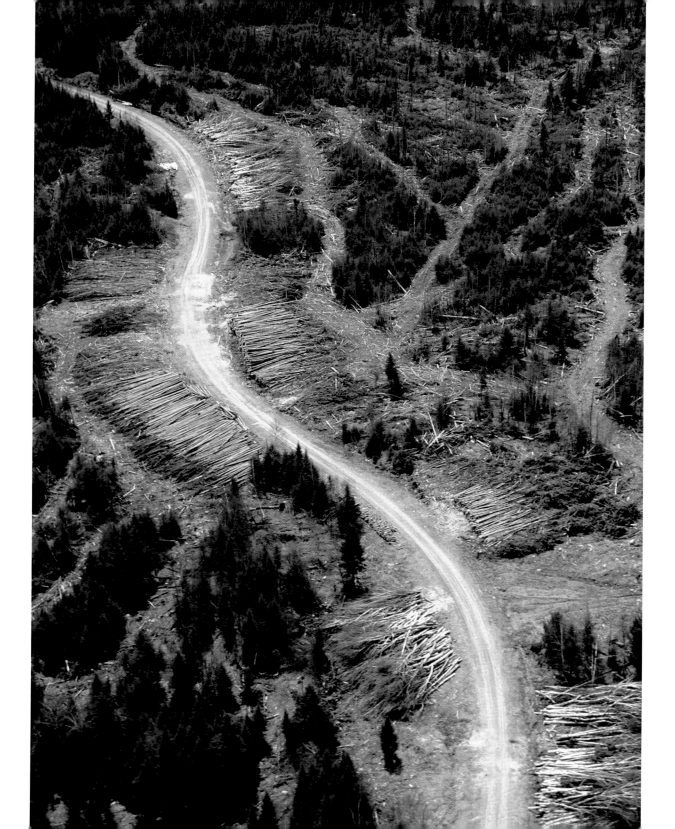

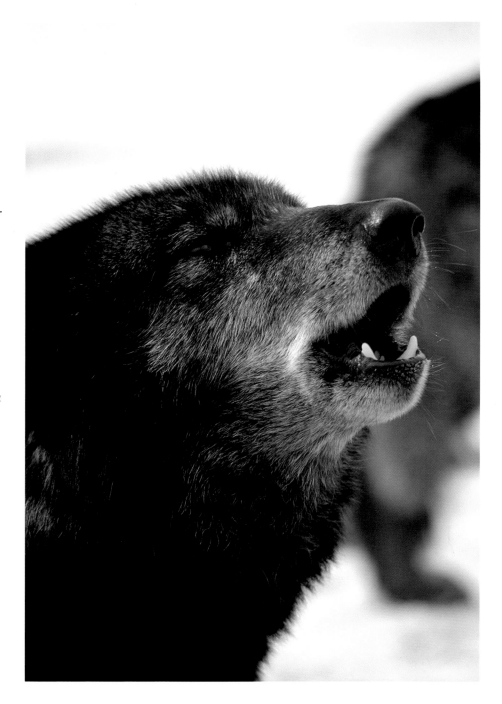

Generally speaking, a howling wilderness does not howl: it is the imagination of the traveller that does the howling.

It was a purely wild and primitive American sound, as much as the barking of a chickaree, and I could not understand a syllable of it . . .

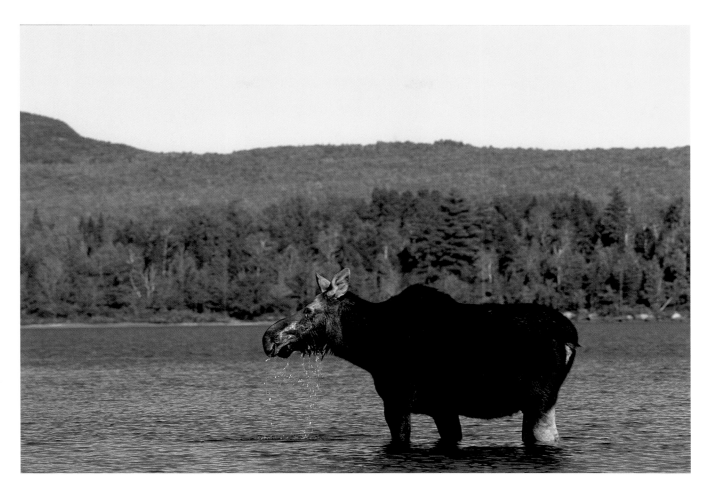

These are God's own horses, poor, timid creatures, that will run

fast enough as soon as they smell you, though they are *nine feet*

high.

The moose is singularly grotesque and awkward to look at. Why

should it stand so high at the shoulders? Why have so long a

head? Why have no tail to speak of?

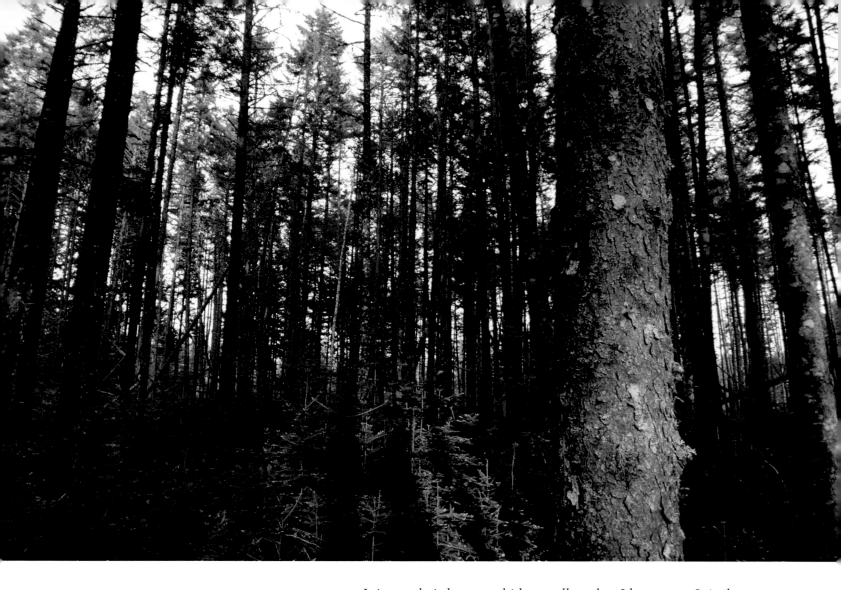

It is not their bones or hide or tallow that I love most. It is the living spirit of the tree, not its spirit of turpentine, with which I sympathize, and which heals my cuts. It is as immortal as I am, and perchance will go to as high a heaven, there to tower above me still.

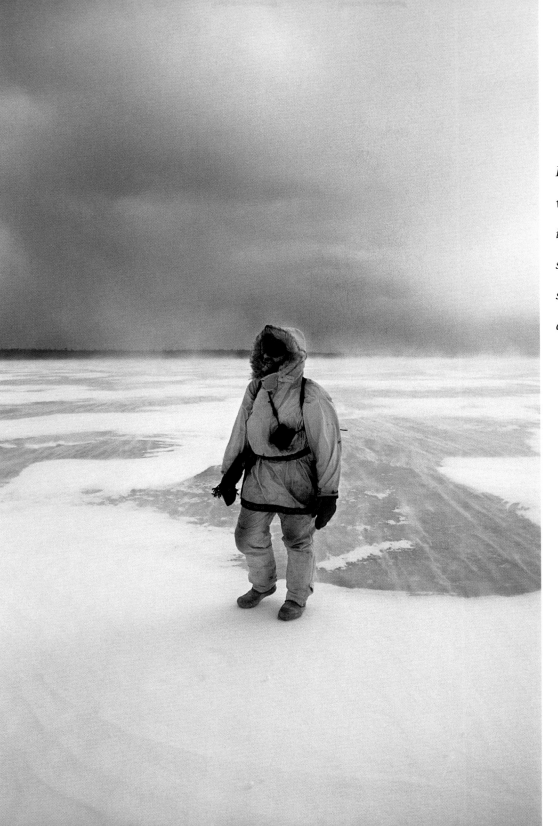

For many years I was self-appointed inspector of snow-storms, and rain-storms, and did my duty faithfully . . .

25

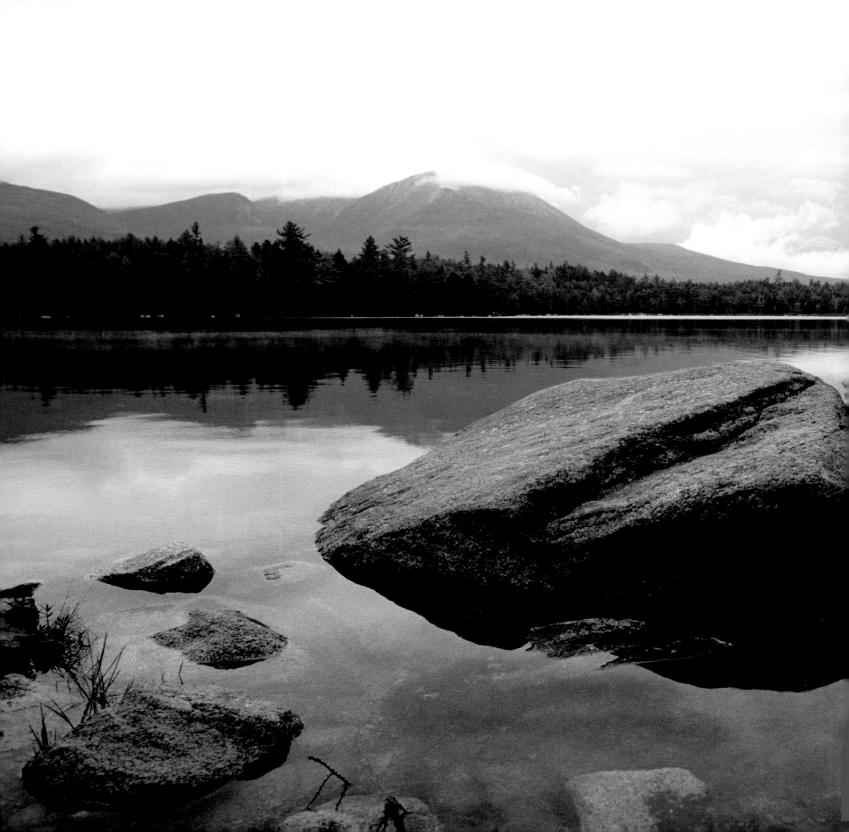

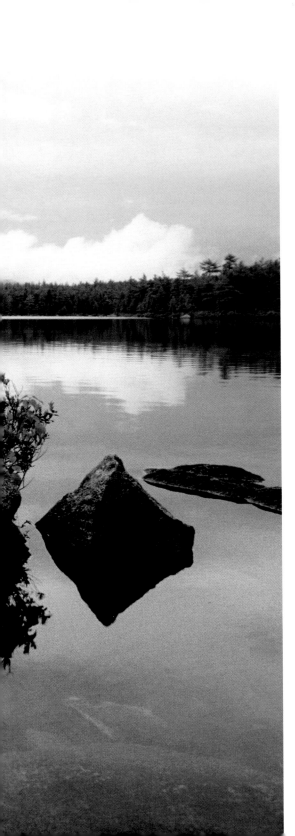

Seen from this point, a bare ridge at the extremity of the open land, Ktaadn presented a different aspect from any mountain I have seen, there being a greater proportion of naked rock rising abruptly from the forest; and we looked up at this blue barrier as if it were some fragment of a wall which anciently bounded the earth in that direction.

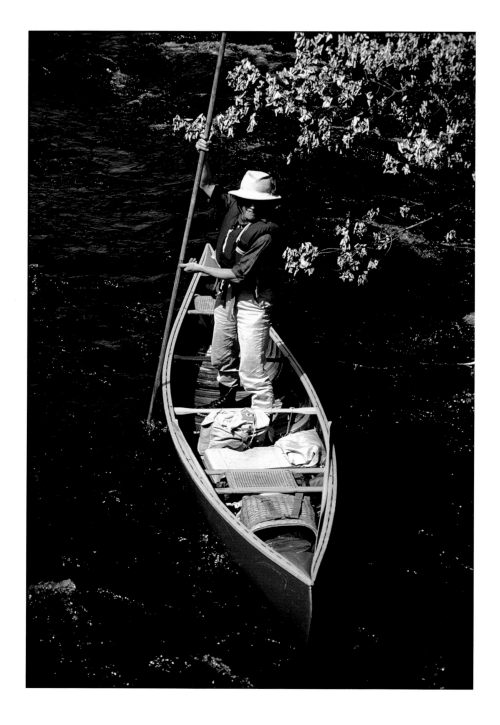

What a glorious time they must have in that wilderness, far from mankind and election day!

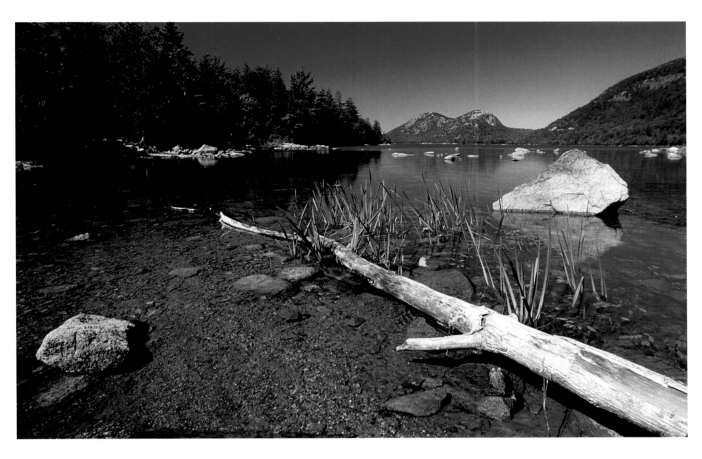

Think of the denseness of the forest, the fallen trees and rocks, the windings of the river, the streams emptying in and the frequent swamps to be crossed. It made you shudder.

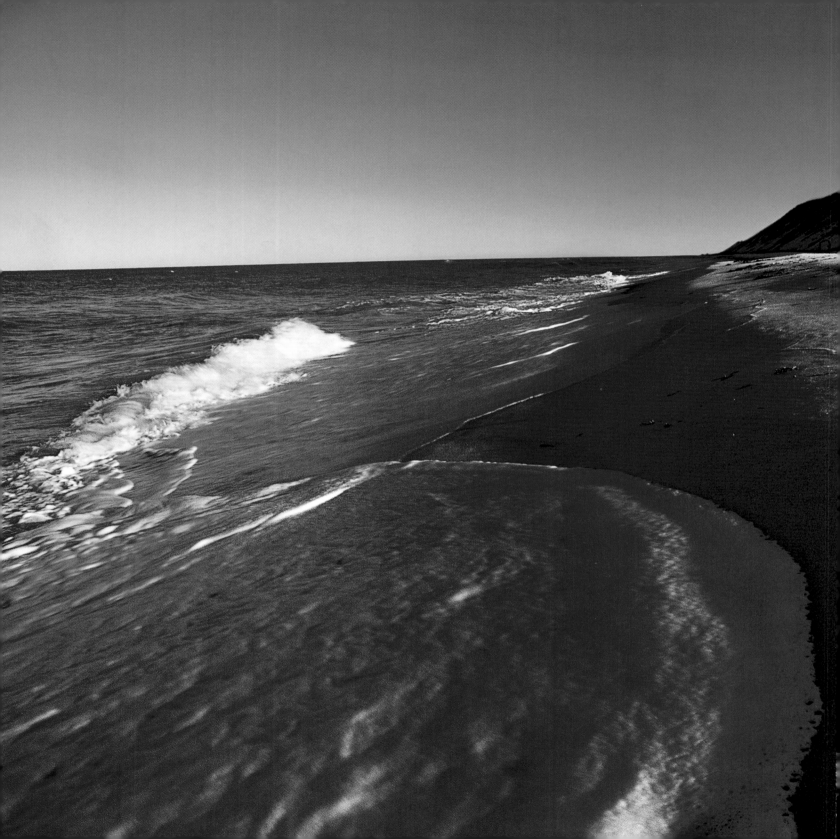

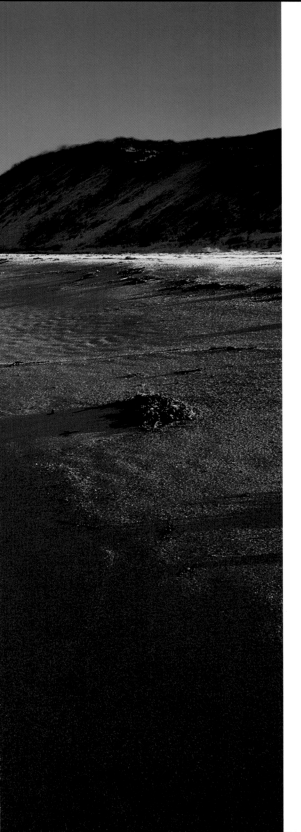

The sea-shore is a sort of neutral ground, a most advantageous point from which to contemplate this world. It is even a trivial place. The waves forever rolling to the land are too far-travelled and untamable to be familiar. Creeping along the endless beach amid the sun-squawl and the foam, it occurs to us that we, too, are the product of sea-slime.

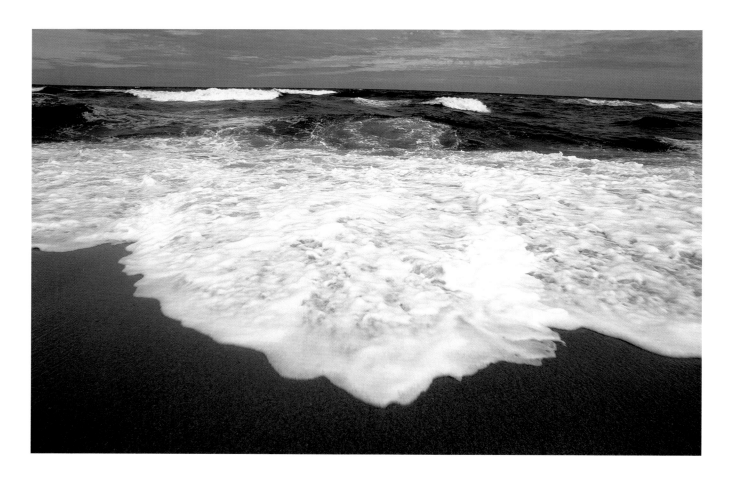

The annals of this voracious beach! who could write them, unless it were a shipwrecked sailor? How many who have seen it have seen it only in the midst of danger and distress, the last strip of earth which their mortal eyes beheld. Think of the amount of suffering which a single strand has witnessed. The ancients would have represented it as a sea-monster with open jaws, more terrible than Scylla and Charybdis.

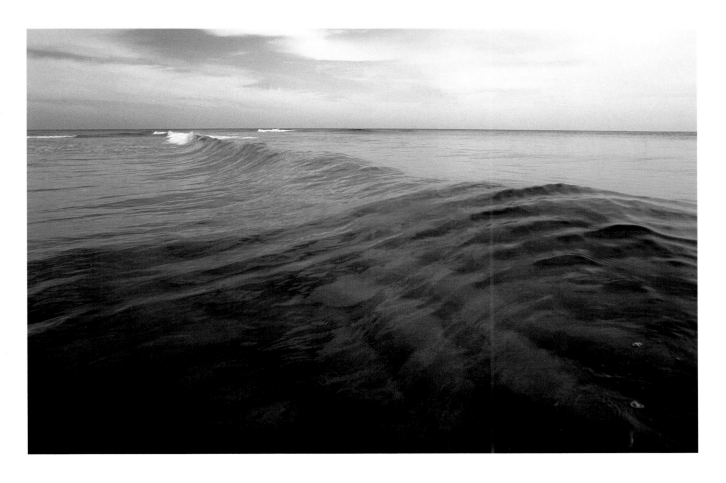

The ocean is a wilderness reaching round the globe, wilder than a Bengal jungle, and fuller of monsters, washing the very wharves of our cities and the gardens of our sea-side residences. Serpents, bears, hyenas, tigers, rapidly vanish as civilization advances, but the most populous and civilized city cannot scare a shark far from its wharves.

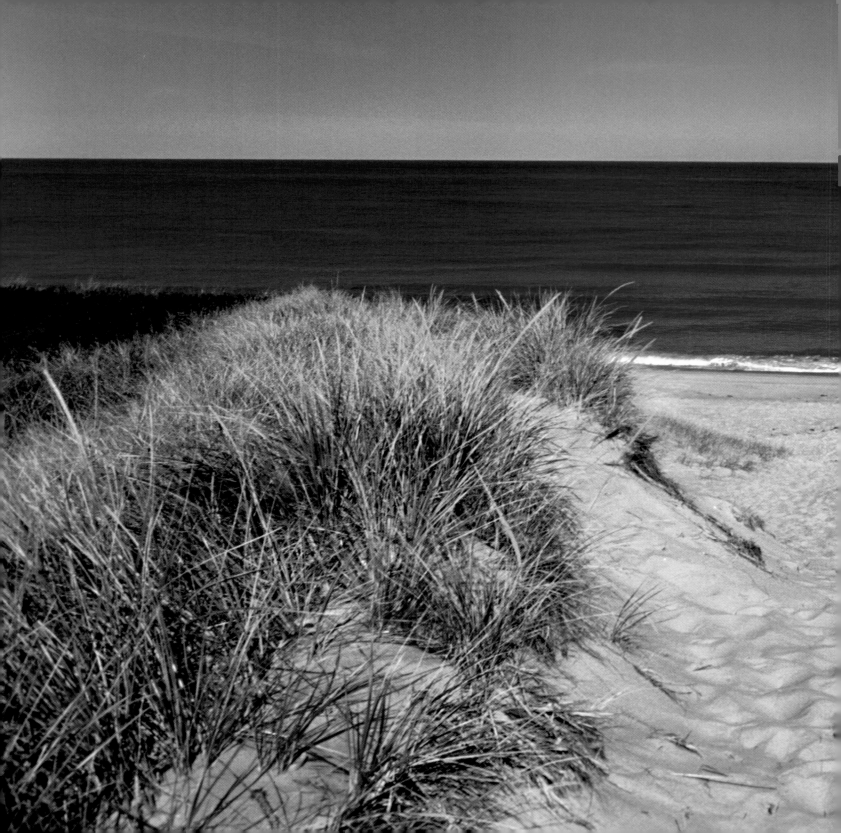

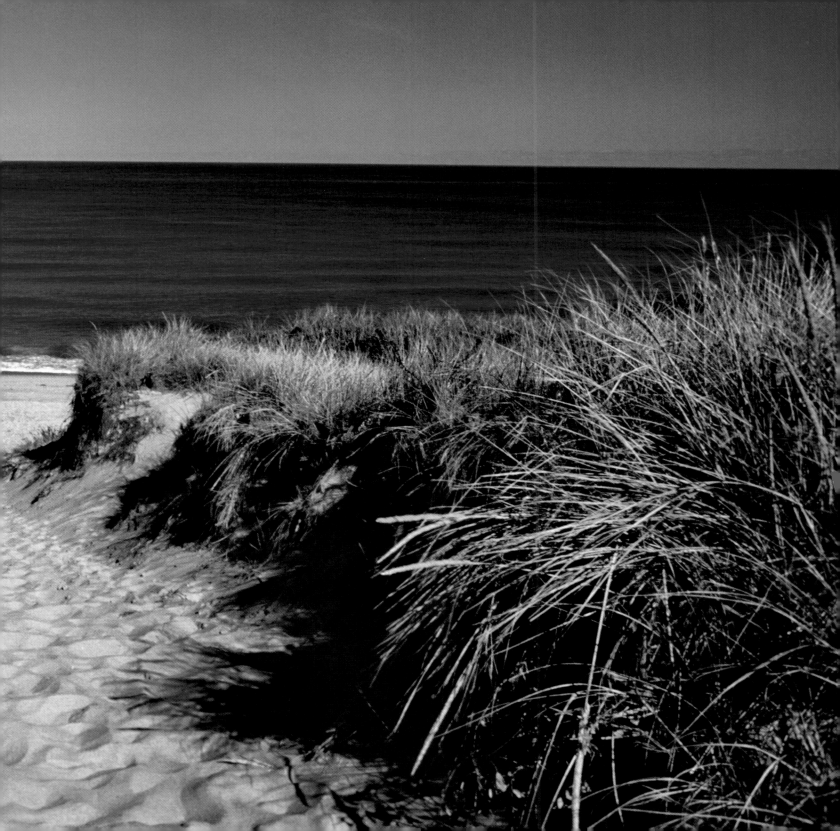

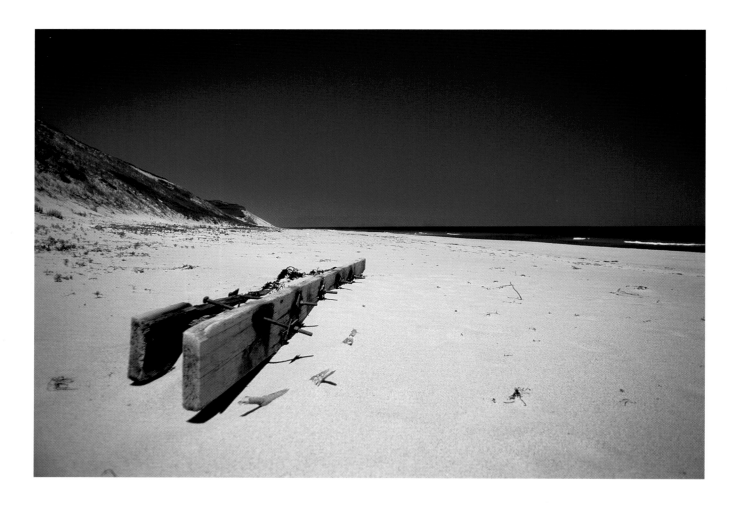

The sea, vast and wild as it is, bears thus the waste and wrecks of human art to its remotest shore. There is no telling what it may not vomit up.

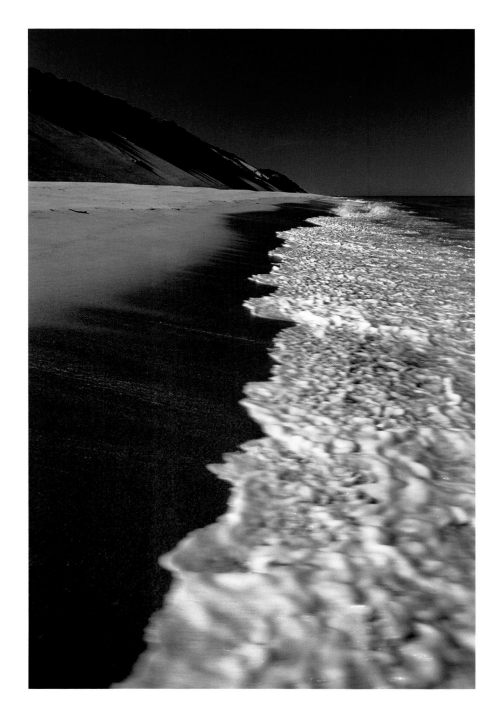

In clear weather the laziest may look across the Bay as far as Plymouth at a glance, or over the Atlantic as far as human vision reaches, merely raising his eyelids; or if he is too lazy to look after all, he can hardly help hearing *the ceaseless dash and roar of the breakers. The restless ocean may at any moment cast up a whale or a wrecked vessel at your feet. All the reporters in the world, the most rapid stenographers, could not report the news it brings.*

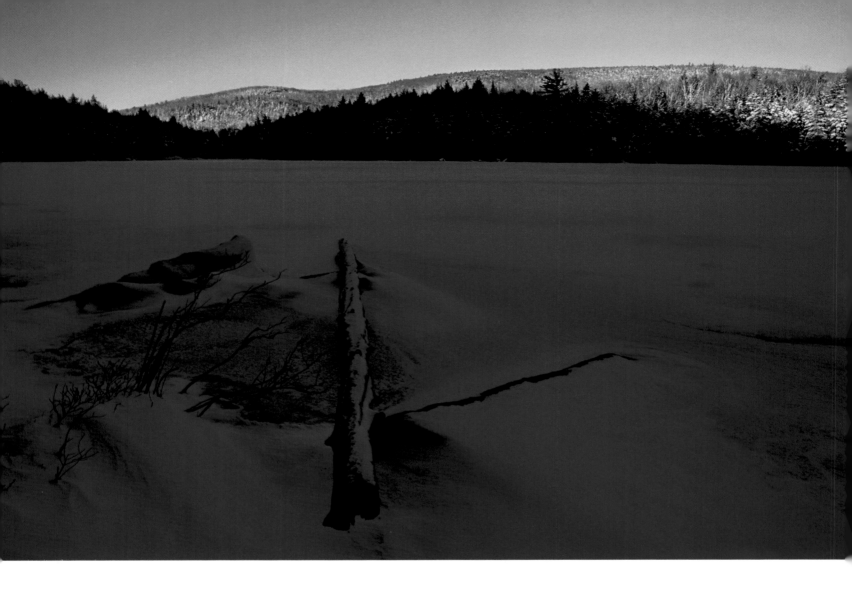

How much more living is the life that is in nature, the furred life
which still survives the stinging nights, and, from amidst fields
and woods covered with frost and snow, sees the sun rise . . .

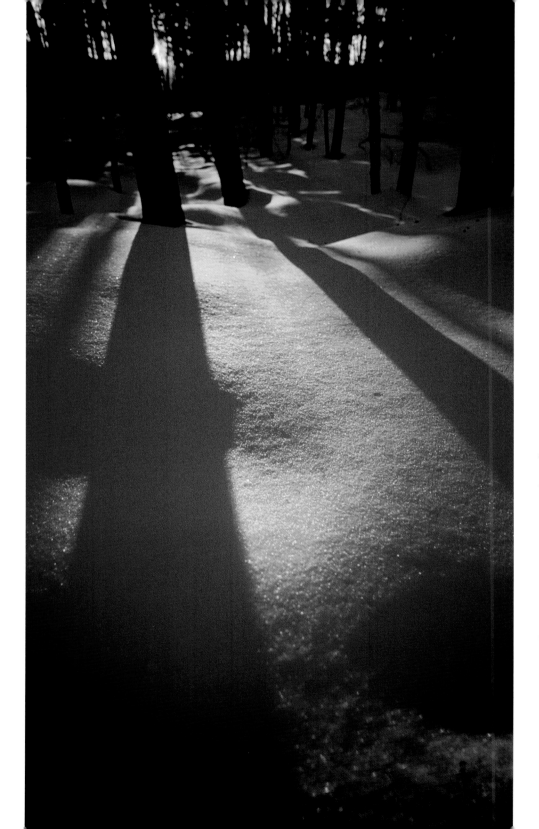

In the winter, I stop short
in the path to admire
how the trees grow up
without forethought,
regardless of the time
and circumstances. They
do not wait as man
does, but now is the
golden age of the sapling.
Earth, air, sun, and rain,
are occasion enough;
they were not better
in primeval centuries.
The "winter of their
discontent" never comes.

We know of no scripture which records the pure benignity of the gods
on a New England winter night. Their praises have never been sung,
only their wrath deprecated. The best scripture, after all, records but a
meagre faith. Its saints live reserved and austere. Let a brave, devout
man spend the year in the woods of Maine or Labrador, and see if the
Hebrew Scriptures speak adequately to his condition and experience,
from the setting in of winter to the breaking up of the ice.

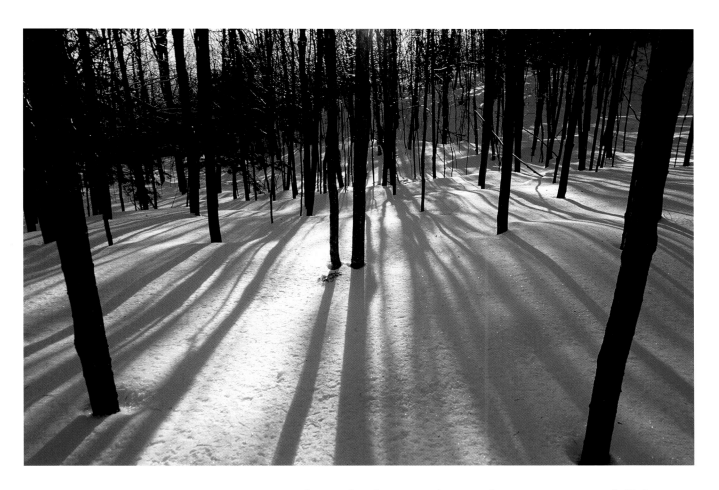

The good Hebrew Revelation takes no cognizance of all this cheerful snow. Is there no religion for the temperate and frigid zones?

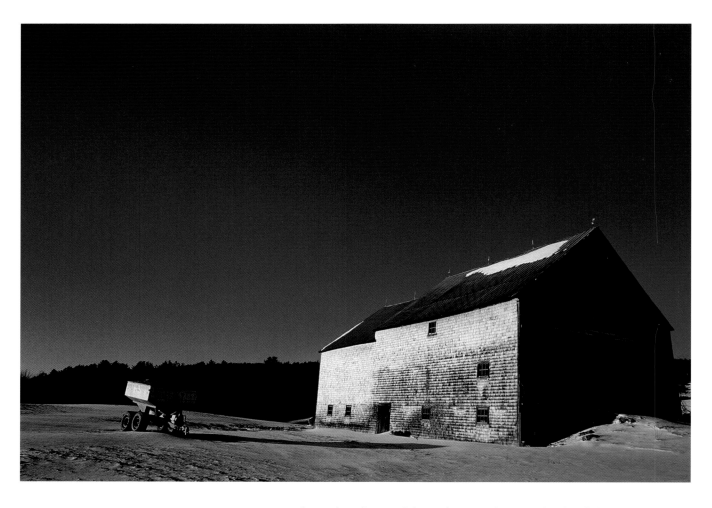

The sight of one of these frontier-houses, built of these great logs, whose inhabitants have unflinchingly maintained their ground many summers and winters in the wilderness, reminds me of famous forts, like Ticonderoga or Crown Point, which have sustained memorable sieges.

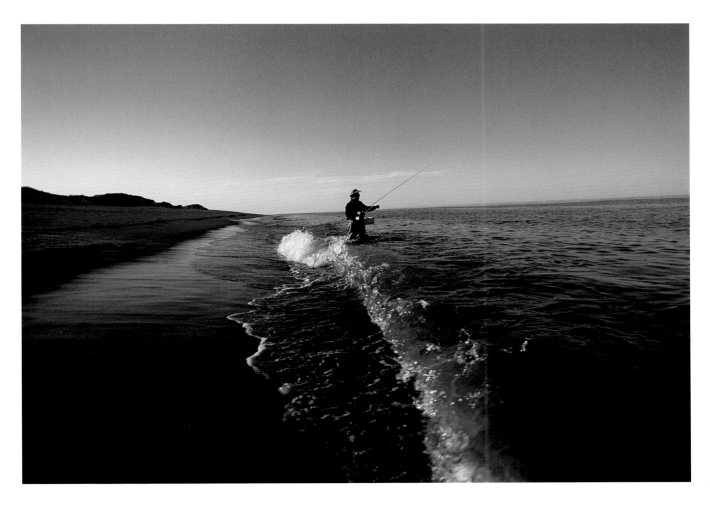

Fishermen, hunters, woodchoppers, and others, spending their lives in the fields and woods, in a peculiar sense a part of Nature themselves, are often in a more favorable mood for observing her, in the intervals of their pursuits, than philosophers or poets even, who approach her with expectation. She is not afraid to exhibit herself to them. The traveller on the prairie is naturally a hunter, on the head waters of the Missouri and Columbia a trapper, and at the falls of St. Mary a fisherman. He who is only a traveller learns things at second-hand and by the halves, and is poor authority.

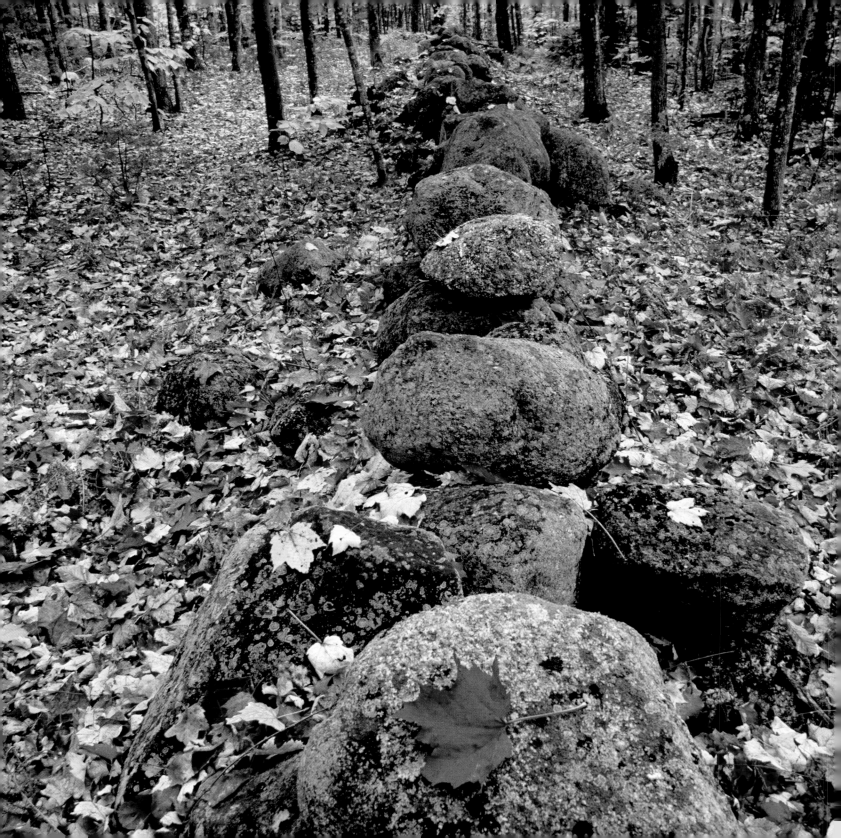

It is pleasant to walk over the beds of these fresh, crisp, and rustling leaves! How beautifully they go to their graves! how gently lay themselves down and turn to mould!

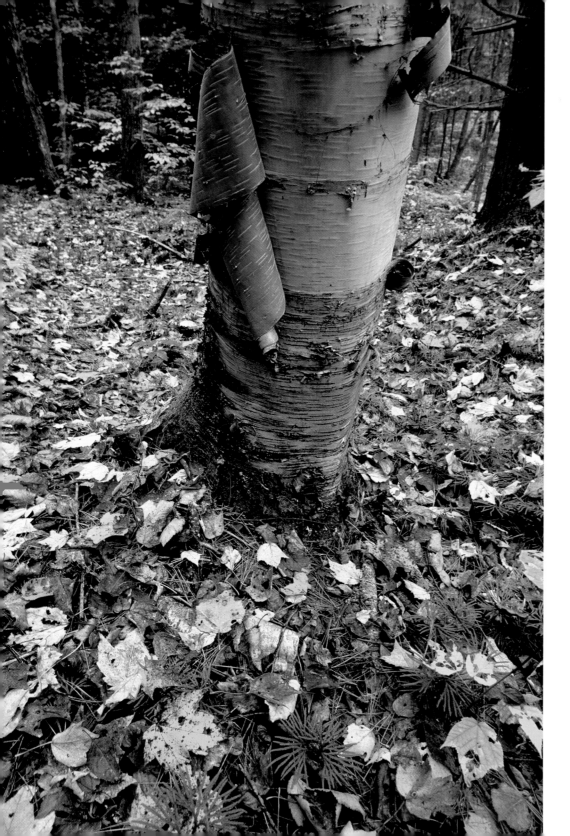

*They that soared so loftily,
how contentedly they return to
dust again, and are laid low,
resigned to lie and decay at
the foot of the tree, and afford
nourishment to new genera-
tions of their kind, as well as
to flutter on high! They teach
us how to die. One wonders if
the time will ever come when
men, with their boasted faith
in immortality, will lie down
as gracefully and as ripe—with
such an Indian-summer seren-
ity will shed their bodies, as
they do their hair and nails.*

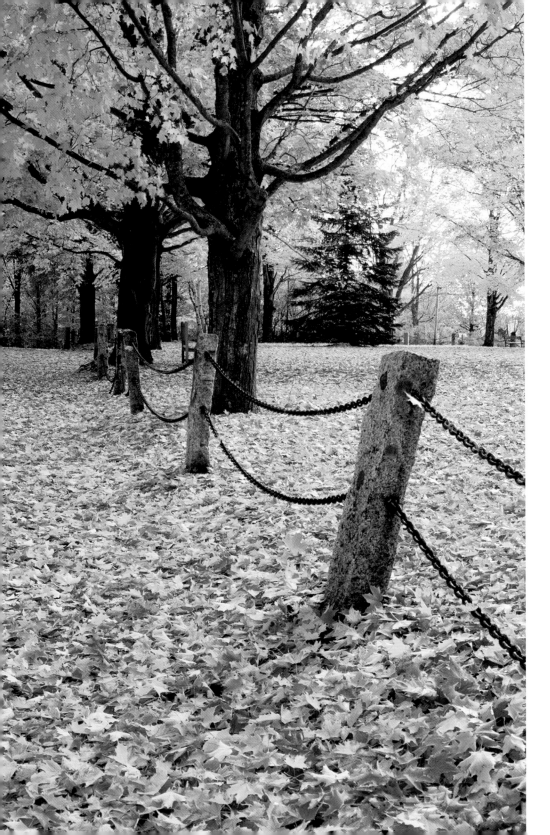

He who rides and keeps the beaten track studies the fences chiefly.

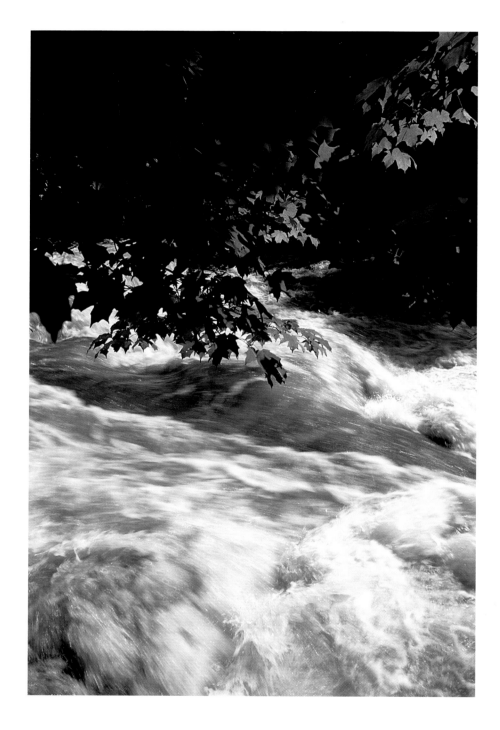

It is even more grim and wild
than you had anticipated, a
damp and intricate wilderness,
in the spring everywhere wet
and miry.

I take infinite pains to know all the phenomena of the spring, for instance, thinking that I have here the entire poem, and then, to my chagrin, I hear that it is but an imperfect copy that I possess and have read, that my ancestors have torn out many of the first leaves and grandest passages, and mutilated it in many places. I should not like to think that some demigod had come before me and picked out some of the best of the stars. I wish to know an entire heaven and an entire earth.

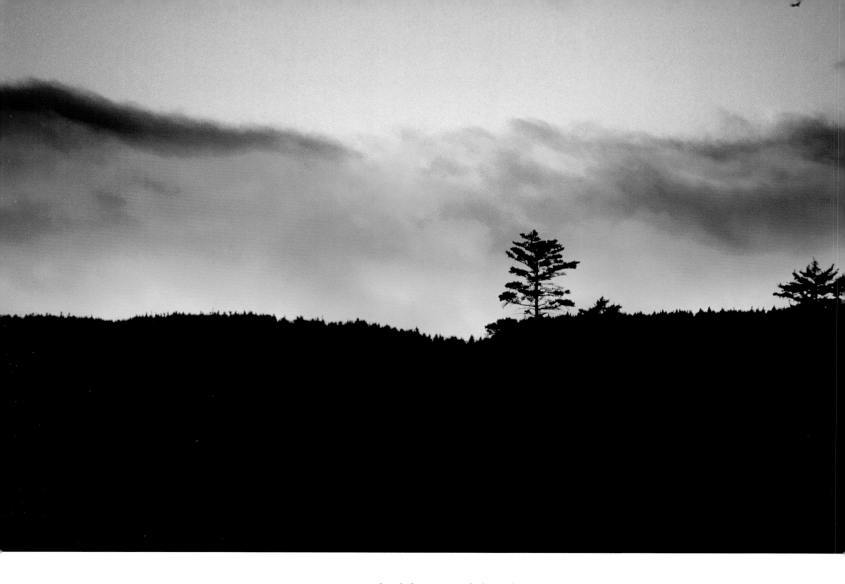

Think how stood the white-pine tree on the shore of the
Chesuncook, its branches soughing with the four winds, and
every individual needle trembling in the sunlight,—think how
it stands with it now,—sold, perchance, to the New England
Friction-Match Company!

It seems as if the more youthful and impressible streams can hardly resist the numerous invitations and temptations to leave their native beds and run down their neighbors' channels.

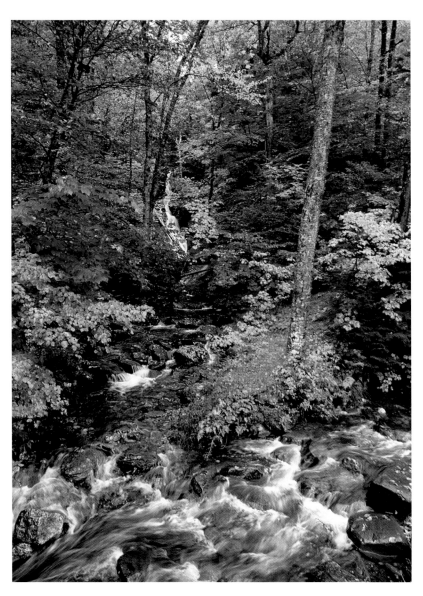

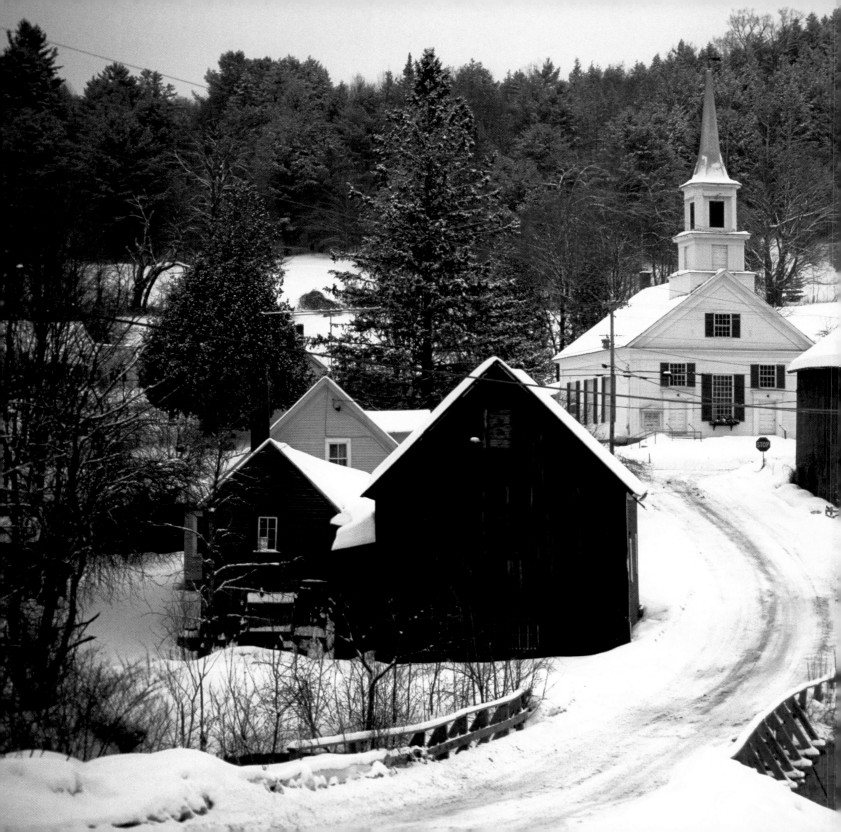

PART II

Society

Henry David Thoreau has often been described as arrogant, insolent, intolerant, and humorless, as the village crank. He relished this persona, and loved to present himself as aloof, as preferring to be alone with his thoughts.

"I never found the companion that was so companionable as solitude," he writes. "To be in company, even with the best, is soon wearisome and dissipating." The portrait he paints of himself is sometimes that of a smug, sanctimonious, self-righteous recluse.

But both his writings and his actions betray him, for *Walden* and his other works are joyful and humorous books, filled with the crackling exuberance of youth. He seemingly has a witty quip or an epigram for every occasion. His public lectures often had the audience doubled over with laughter. Despite his efforts at presenting himself as an ascetic, his wonderful sense of humor shines through in his writing, as does his glee at playing the role of the contrarian. He delights in shocking us by tipping sacred cows, all the while prodding us to think independently and to live the lives we imagine we are capable of living.

And in contrast to the persona he polished, Thoreau was hardly a hermit. His cabin at Walden Pond was a mere half-hour walk from the center of Concord, where his rambles took him almost daily.

He loved to be around people, and he cultivated strong friendships. He was quite an athlete, and we have reports of him ice skating on the frozen Concord River, swooping and jumping with joy while his companions gamely tried to keep up. He doted on children, and they adored him in return. And, except for the two years and two months he spent at Walden and his college days at Harvard, he basked in the warm comfort of his family until the day he died.

Rather than an example of penance and self-denial, Thoreau's life and work stand as a defense of nonconformity, and an insistence that life should be neither a burden nor an obligation, but rather a merry exploration and adventure. Live deliberately, he urges us, live happily, and "Explore thyself."

I say, beware of all enterprises that require new clothes, and not rather a new wearer of clothes.

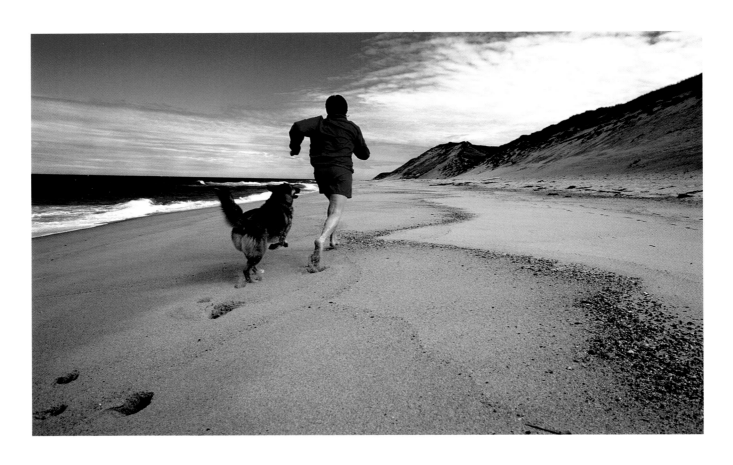

I have met with but one or two persons in the course of my life

who understood the art of Walking, that is, of taking walks, who

had a genius, so to speak, for sauntering . . .

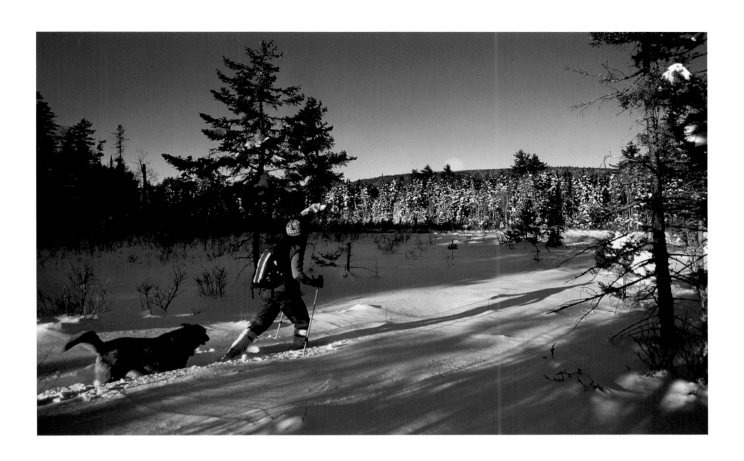

I think that I cannot preserve my health and spirits unless I spend four hours a day at least—and it is commonly more than that—sauntering through the woods and over the hills and fields absolutely free from all worldly engagements.

If you are ready to leave father and mother, and brother and sister, and wife and child and friends, and never see them again; if you have paid your debts, and made your will, and settled all your affairs, and are a free man; then you are ready for a walk.

In my afternoon walk I would fain forget all my morning occupations, and my obligation to society. But it sometimes happens that I cannot easily shake off the village. The thought of some work will run in my head, and I am not where my body is; I am out of my senses.

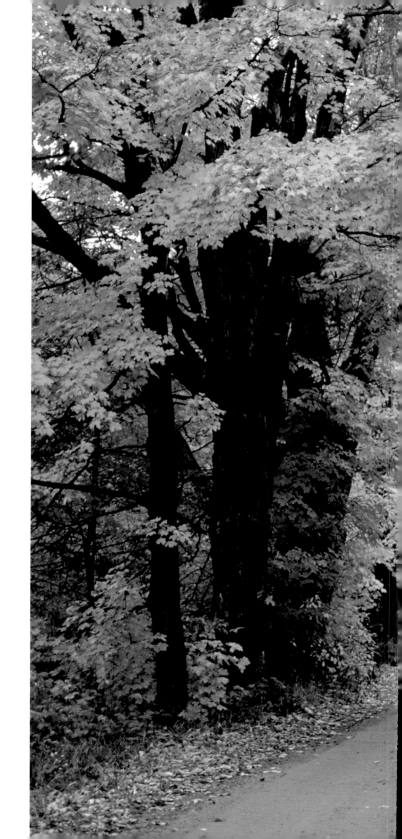

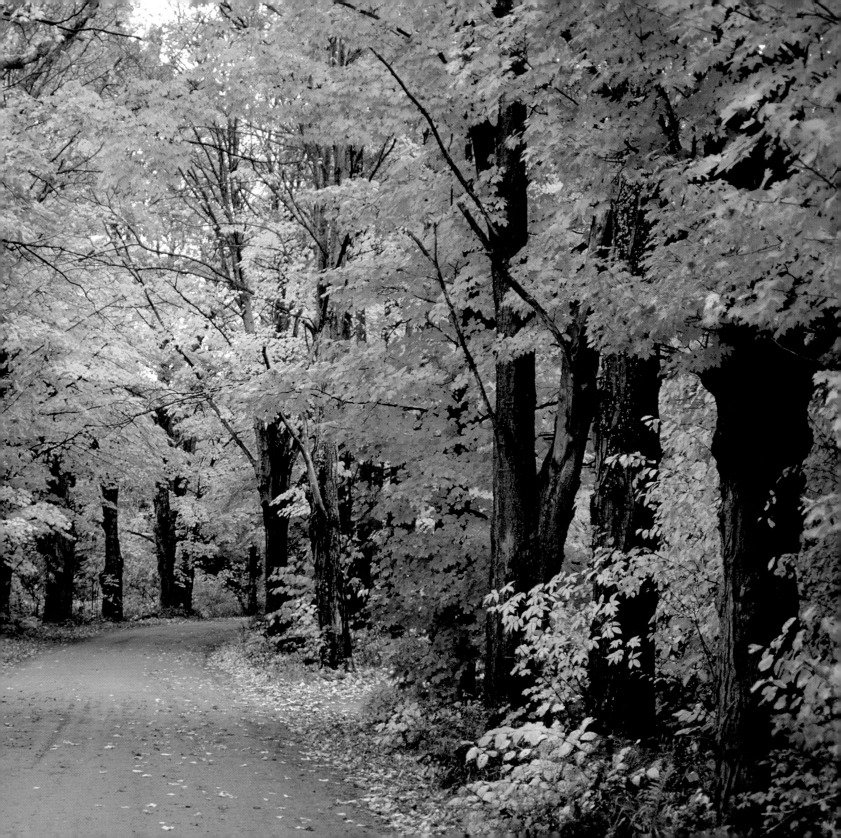

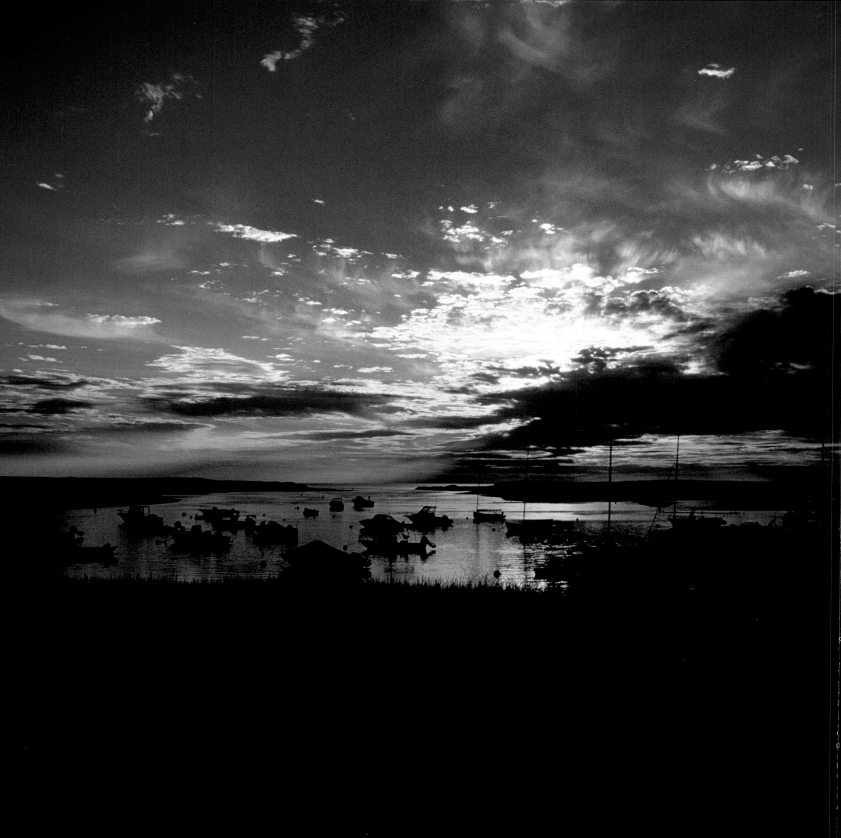

In any weather, at any hour of the day or night, I have been anx-
ious to improve the nick of time, and notch it on my stick too;
to stand on the meeting of two eternities, the past and future,
which is precisely the present moment; to toe that line.

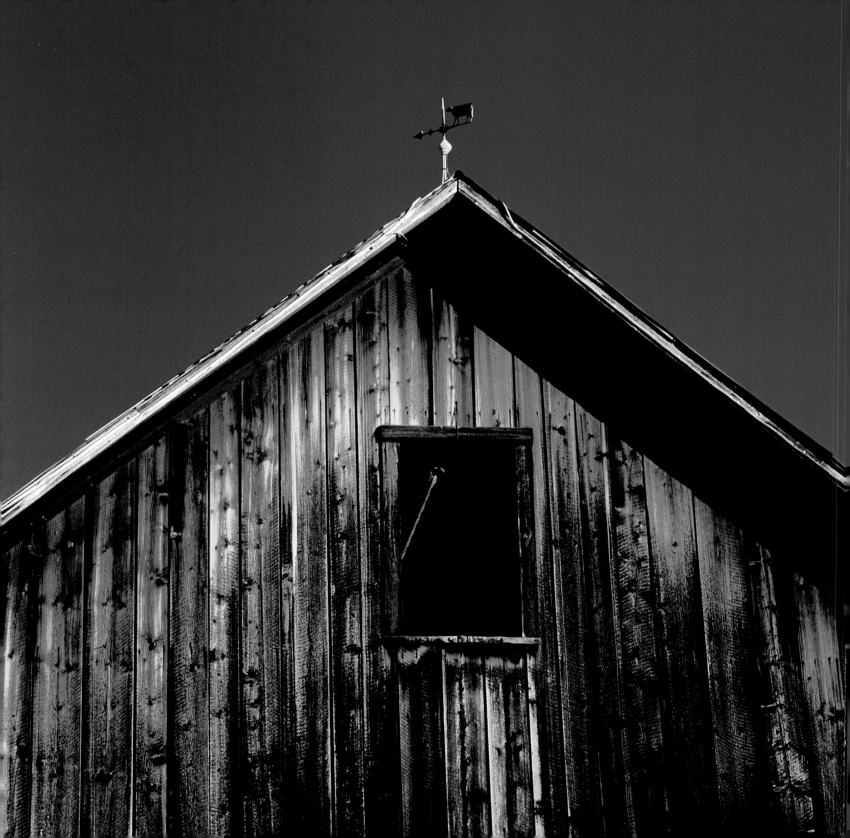

I rejoice that horses and steers have to be broken before they can be made the slaves of men, and that men themselves have some wild oats still left to sow before they become submissive members of society. Undoubtedly, all men are not equally fit subjects for civilization, and because the majority, like dogs and sheep are tame by inherited disposition, is no reason why the others should have their natures broken that they may be reduced to the same level.

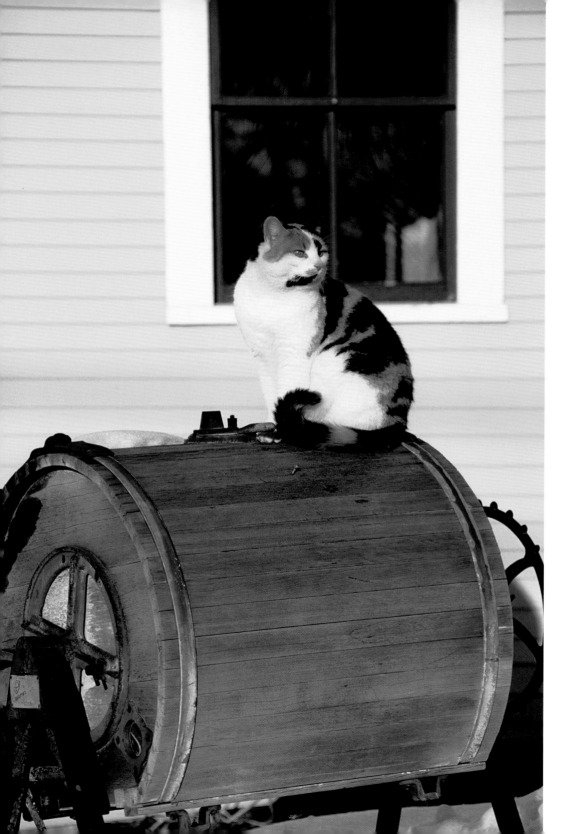

To affect the quality of the day, that is the highest of arts.

We do not live for idle amusement. I would not run round a corner to see the world blow up.

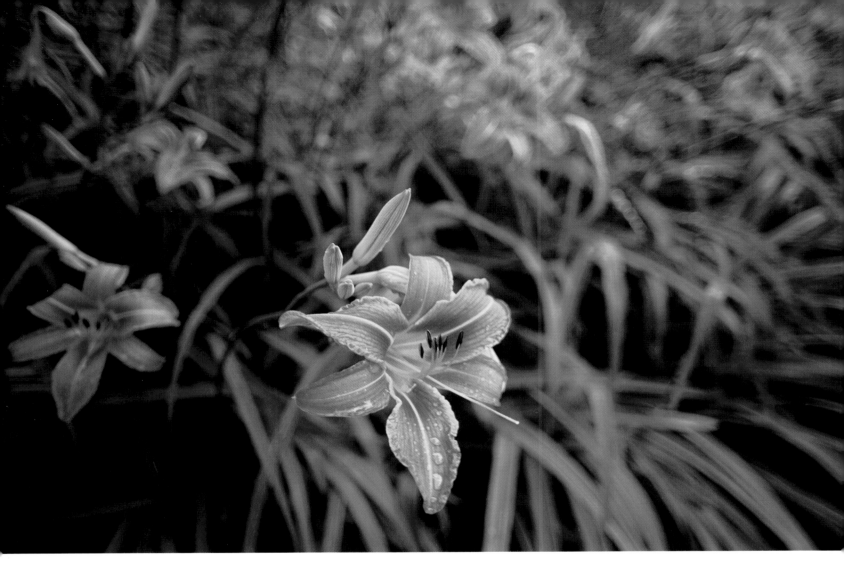

The perception of beauty is a moral test.

All nature is your congratulation, and you have cause
momentarily to bless yourself.

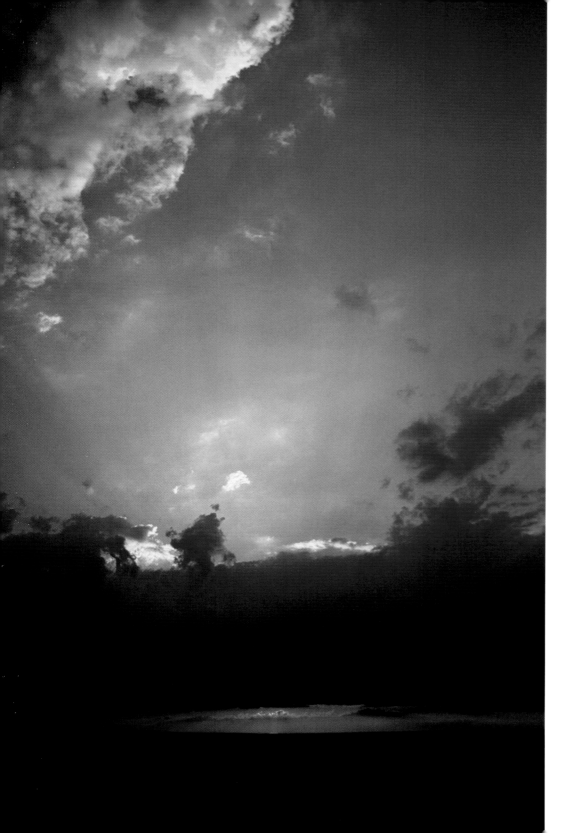

We must learn to reawaken

and keep ourselves awake, not

by mechanical aids, but by

an infinite expectation of the

dawn . . .

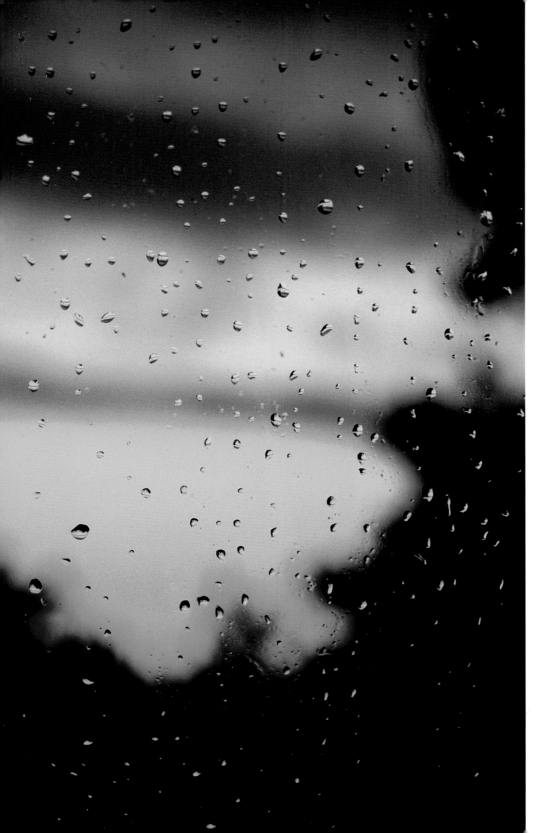

What is the use of a house

if you haven't got a tolerable

planet to put it on?

How does it become a man to

behave toward the American

government today? I answer,

that he cannot without

disgrace be associated with it.

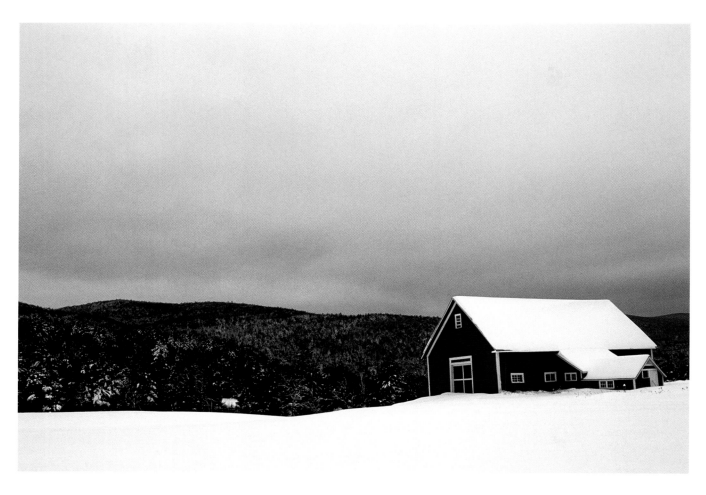

Our village life would stagnate if it were not for the unexplored forests and meadows which surround it. We need the tonic of wildness,—to wade sometimes in marshes where the bittern and the meadow-hen lurk, and hear the booming of the snipe; to smell the whispering sedge where only some wilder and more solitary fowl builds her nest, and the mink crawls with its belly close to the ground.

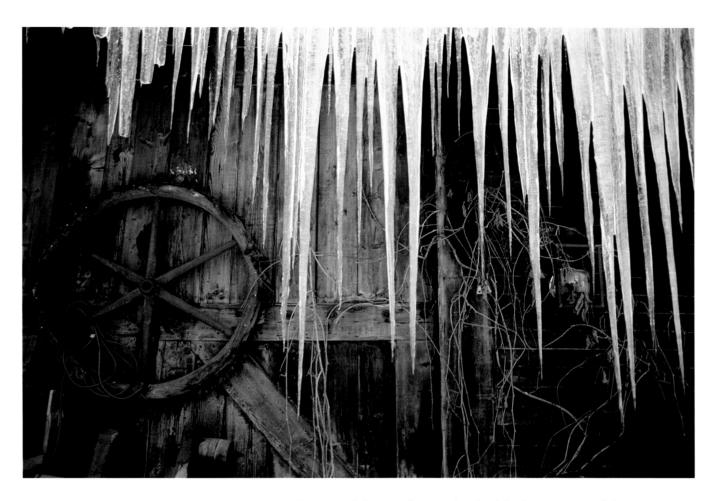

But men labor under a mistake. The better part of the man is soon plowed into the soil for compost. By a seeming fate, commonly called necessity, they are employed, as it says in an old book, laying up treasures which moth and rust will corrupt and thieves break through and steal. It is a fool's life, as they will find when they get to the end of it, if not before.

If you have built castles in the air, your work need not be lost; that is where they should be. Now put the foundations under them.

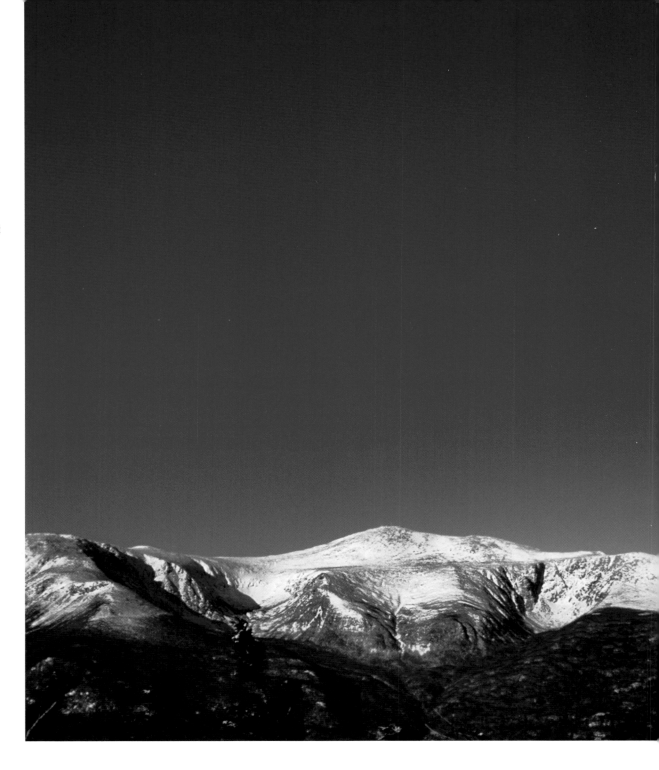

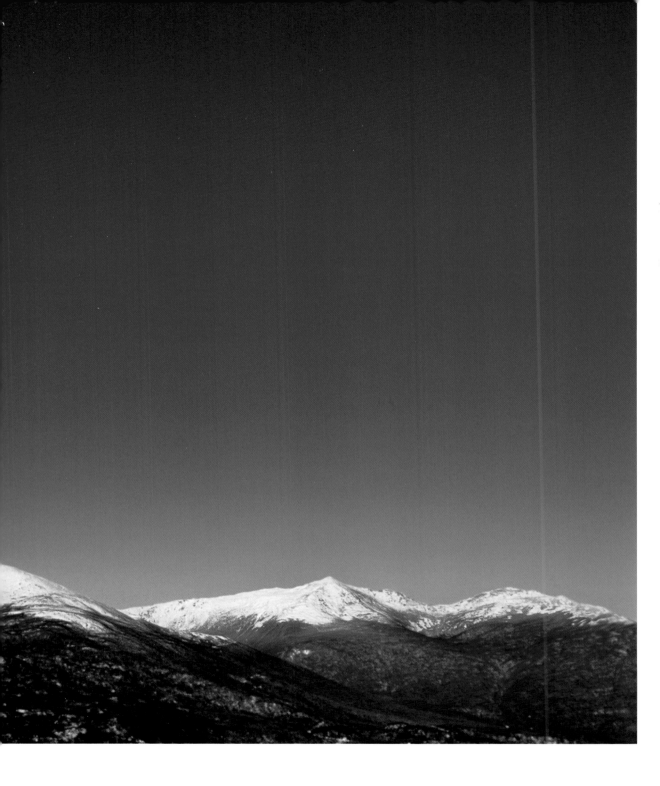

*Read not the
Times. Read
the Eternities.*

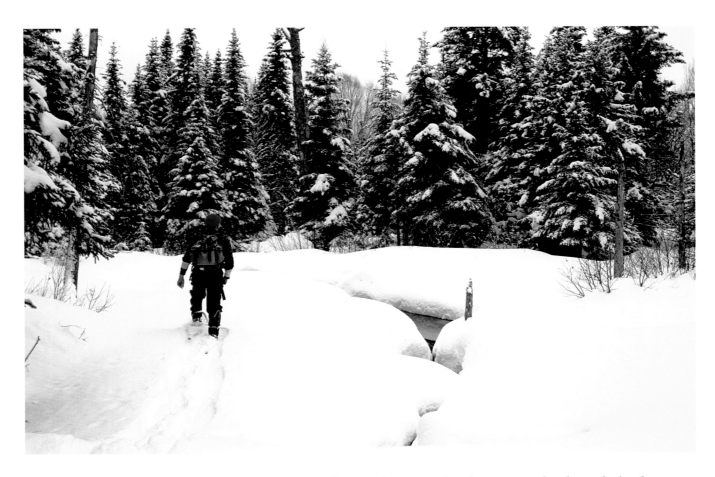

. . . I frequently tramped eight or ten miles through the deepest snow to keep an appointment with a beech tree, or a yellow birch, or an old acquaintance among the pines . . .

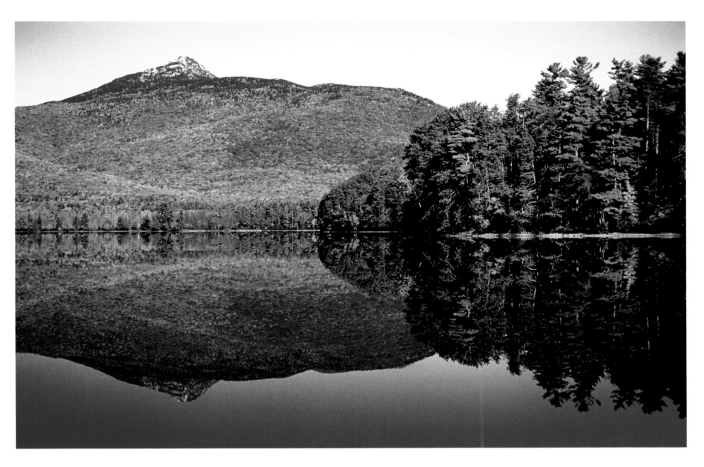

I wish to speak a word for Nature, for absolute Freedom and Wildness, as contrasted with a Freedom and Culture merely civil,—to regard man as an inhabitant, or a part and parcel of Nature, rather than a member of society. I wish to make an extreme statement, if so I may make an emphatic one, for there are enough champions of civilization; the minister, and the school-committee, and every one of you will take care of that.

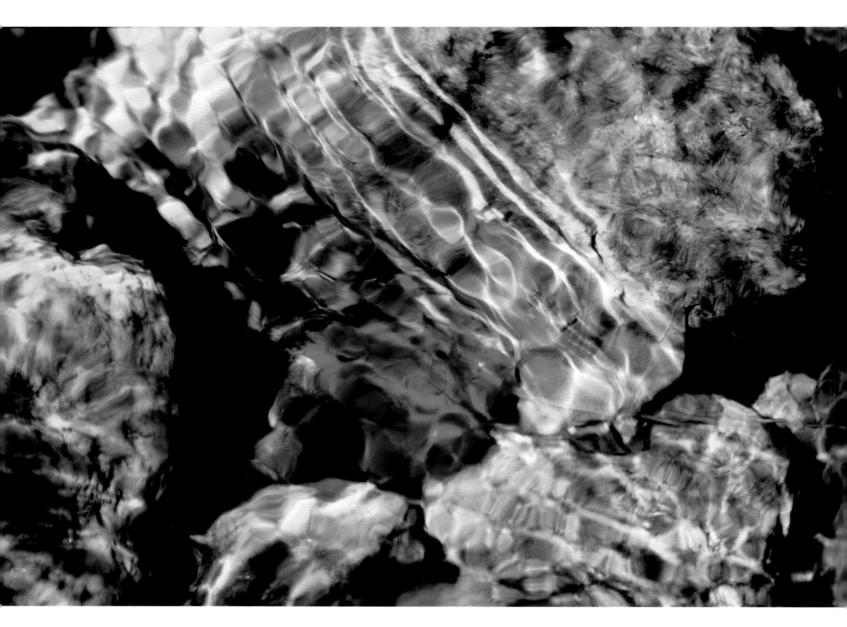

The question is not what you look at, but what you see.

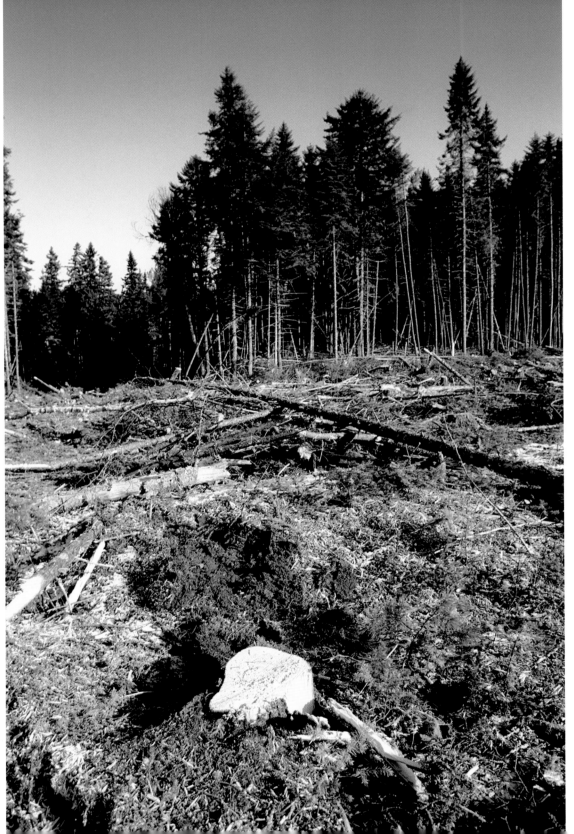

There are a thousand hacking at the branches of evil to one who is striking at the root . . .

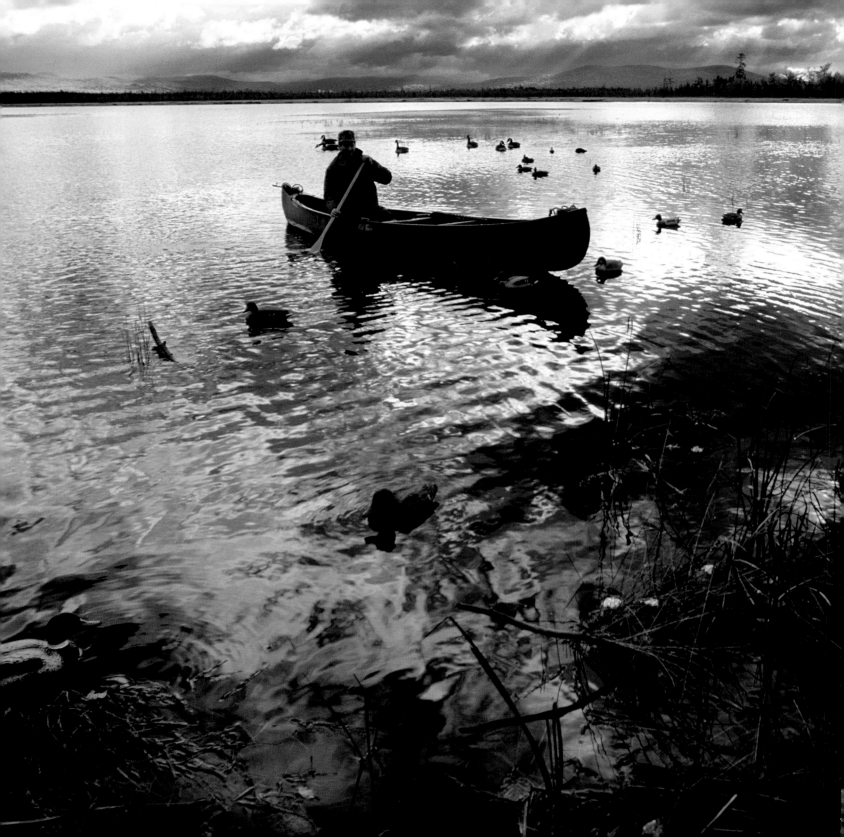

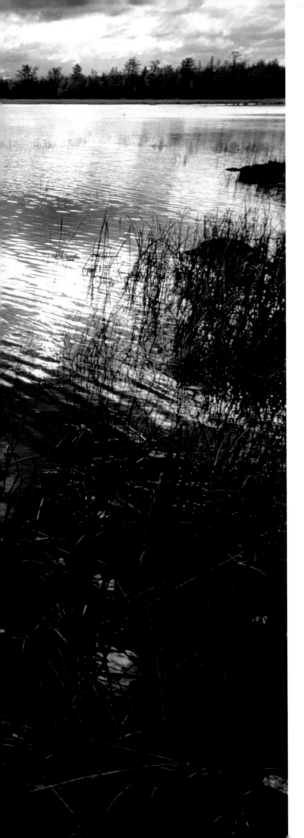

Our life is frittered away by detail. An honest man has hardly need to count more than his ten fingers, or in extreme cases he may add his ten toes, and lump the rest. Simplicity, simplicity, simplicity! I say, let your affairs be as two or three, and not a hundred or a thousand; instead of a million count half a dozen, and keep your accounts on your thumb nail.

But I foresee, that, if my wants should be much increased, the labor required to supply them would become a drudgery. If I should sell both my forenoons and afternoons to society, as most appear to do, I am sure, that, for me, there would be nothing left worth living for.

77

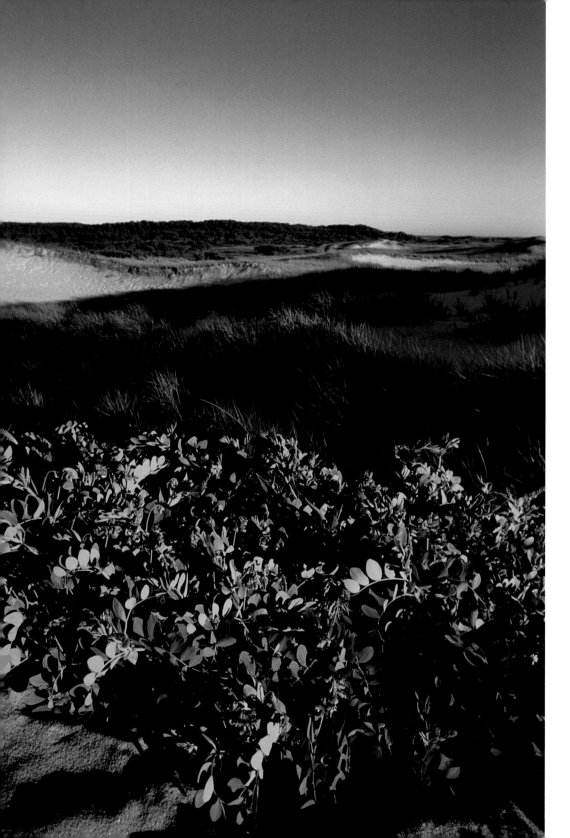

*Live in each season as it
passes; breathe the air, drink
the drink, taste the fruit, and
resign yourself to the influences
of each. . . . Be blown on by all
the winds. Open all your pores
and bathe in all the tides of
Nature, in all her streams and
oceans, at all seasons.*

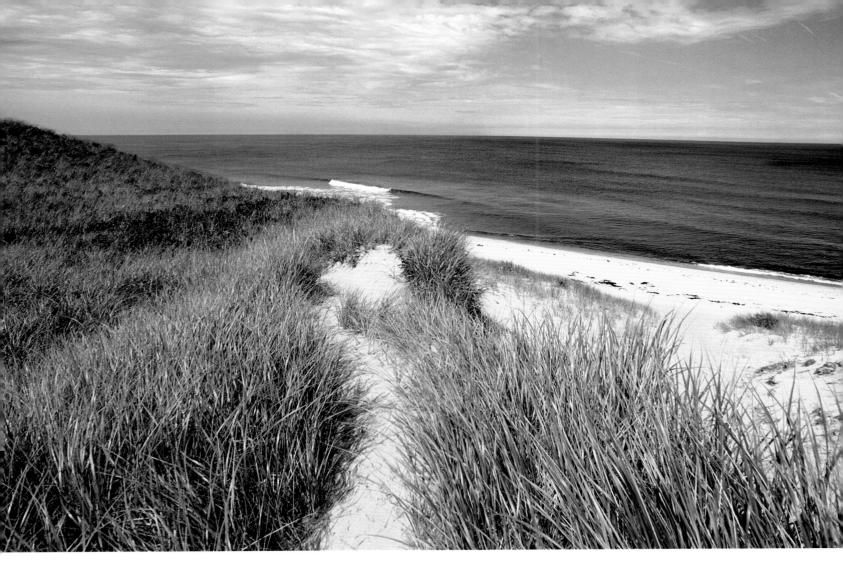

A man may stand there and put all America behind him.

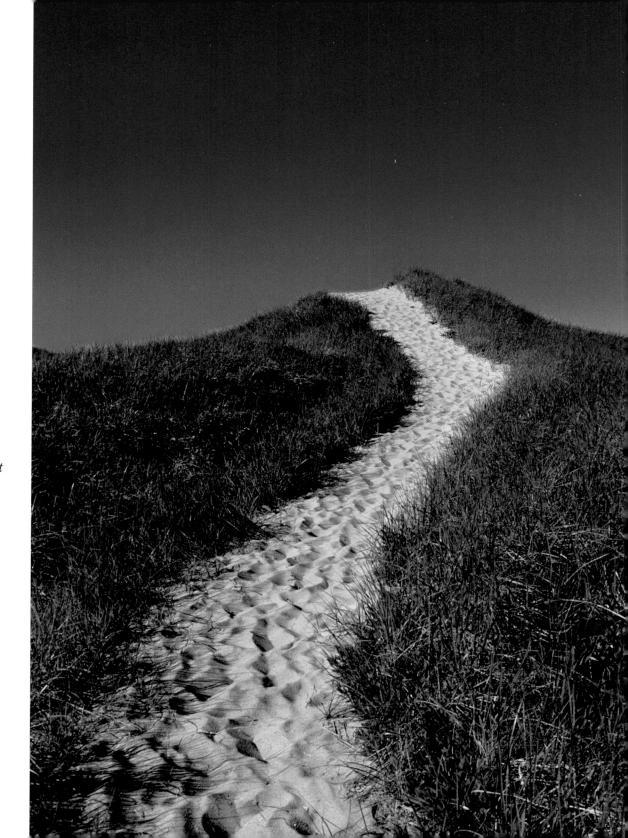

*If I knew for a cer-
tainty that a man
was coming to my
house with the
conscious design of
doing me good, I
should run for my
life . . .*

*You must love the
crust of the earth
on which you dwell
more than the sweet
crust of any bread
or cake. You must
be able to extract
nutriment out of a
sand-heap.*

Epilogue

I left the woods for as good a reason as I went there. Perhaps it seemed to me that I had several more lives to live, and could not spare any more time for that one. It is remarkable how easily and insensibly we fall into a particular route, and make a beaten track for ourselves.

—Henry David Thoreau

SOURCES

Though he sold but few volumes of his works during his short lifetime, Thoreau has been a posthumous perennial best-selling author, and today his works are available in dozens of editions and countless printings in numerous languages throughout the world. By some estimates he is the all-time best-selling author in the English language.

I have been collecting Thoreau's quips and epigrams for many years, drawing from many of these various sources. An excellent place to look up your own favorite Thoreau quotes is on the web at Project Gutenberg www.gutenberg.org, an online library of 17,000 free electronic books in the public domain; or else of course you can find hard copies of Thoreau's works at your local neighborhood bookstore, or anywhere books are sold.

Finally, sometimes when I travel I carry my little palm-sized editions of Thoreau's works: *Backwoods and Along the Seashore: Selections from The Maine Woods and Cape Cod*, published by Shambala Publications in 1994; also *Walden, Or, Life in the Woods*, published by Shambala Publications in 1992. These volumes were both in their Pocket Classics series. They are now out of print but if you want to keep Thoreau handy you can still purchase these little editions from online bookstores.

The quotes in this book were drawn from the following Thoreau works:

Page ix: *Walden*
Page 5: *The Maine Woods; The Maine Woods; Cape Cod;* "Walking"
Page 6: *Walden*
Page 7: *Walden*
Page 9: *The Maine Woods*
Page 11: *The Maine Woods; The Maine Woods*
Page 12: *The Maine Woods*
Page 13: *The Maine Woods*
Page 17: "Walking;" *The Maine Woods*
Page 18: *The Maine Woods*
Page 19: *The Maine Woods*
Page 20: *The Maine Woods*
Page 22: *The Maine Woods; The Maine Woods*
Page 23: *The Maine Woods; The Maine Woods*
Page 24: *The Maine Woods*
Page 25: *Walden*
Page 27: *The Maine Woods*
Page 28: *The Maine Woods*
Page 29: *The Maine Woods*
Page 31: *Cape Cod*
Page 32: *Cape Cod*